POSING *for*
PORTRAIT PHOTOGRAPHY

a head-to-toe guide

Jeff Smith

AMHERST MEDIA, INC. ■ BUFFALO, NY

Copyright © 2004 by Jeff Smith.
All rights reserved.

Published by:
Amherst Media, Inc.
P.O. Box 586
Buffalo, N.Y. 14226
Fax: 716-874-4508
www.AmherstMedia.com

Publisher: Craig Alesse
Senior Editor/Production Manager: Michelle Perkins
Assistant Editor: Barbara A. Lynch-Johnt

ISBN: 1-58428-134-9
Library of Congress Card Catalog Number: 2003112490

Printed in Korea.
10 9 8 7 6 5 4 3 2 1

Notice of Disclaimer: The information contained in this book is based on the author's experience and opinions. The author and publisher will not be held liable for the use or misuse of the information in this book.

TABLE OF CONTENTS

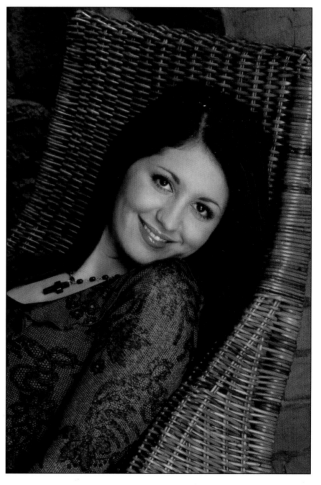

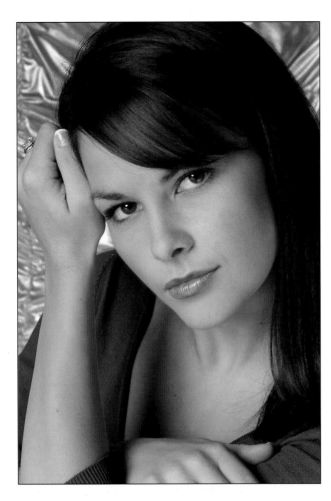

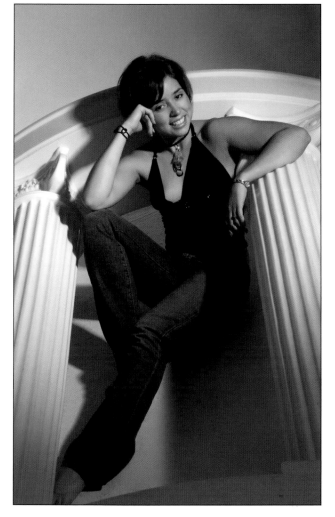

INTRODUCTION

he human form. It can be shaped and proportioned to be one of the most beautiful subjects on earth. At the same time, the body can be arranged in a such way that it makes even the most attractive person look disfigured.

Further complicating this arrangement of the human form are all the different shapes and sizes of people that we, as professional photographers, must work with. It is one thing to make a perfect model look good during a test session or seminar—but use the same poses on a good portion of our average customer base, and you will end up with an unsaleable portrait.

So, what is it that makes one arrangement of body parts look so graceful, while another arrangement looks so awkward? That is the subject of this book. But before we look at the mechanics of posing, there are a few other things to keep in mind if we hope to successfully work with our clients and sell our images. These are detailed below.

What is it that makes one arrangement of body parts look so graceful, while another arrangement looks so awkward?

■ Salable Posing

Salable posing is much different than artistic posing. Show a larger woman of today a portrait of a larger woman painted by one the old masters and she will say that it is art. Take a portrait of that same woman of today in the exact same pose, and she will say she looks like the Pillsbury Dough Boy. As you can see from this example, creating a salable pose is a complicated issue.

Obstacles to Salable Posing. The first thing to understand is that you must select a pose based on the needs and tastes of the indi-

In traditional posing, women were supposed to look passive. That just doesn't suit the women of today.

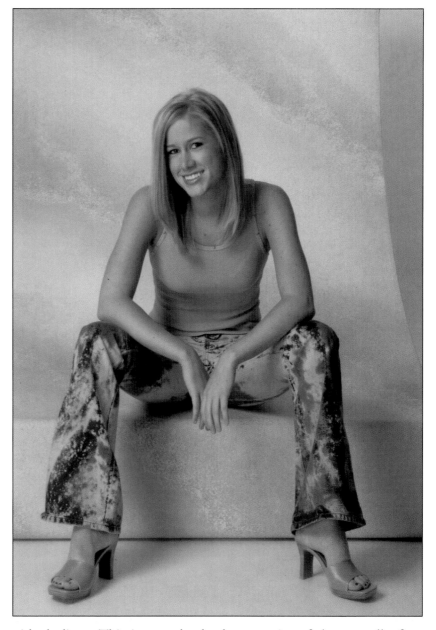

The greatest hurdle photographers must make is getting over the "photographers know best" way of thinking.

vidual client. This is completely the opposite of the way all of us learn photography. We are taught that every detail of every portrait we take should be selected to fit our taste and designed for our own purposes. The greatest hurdle photographers must make is getting over the "photographers know best" way of thinking. Most photographers like to think of themselves as artists, free spirits who get to create little works of art—but someone else has to live with that "art." And in the end, the client and their money will determine if it is art or not! The truth is that art is in the eye of the buyer, not the creator.

Tradition is another old friend of photographers that must be dealt with. The outdated and obsolete theories of posing taught to young photographers as a start for learning classic art theory are

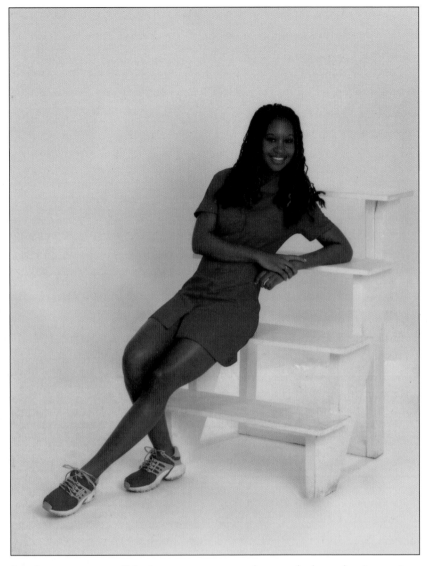

hard to get past. It's important to understand that classic posing theories came from a different place and a much different time.

Let's take women for example. In the era that inspired much of our posing theories of today, women were expected to be passive and submissive. It was a man's world, and men allowed women to live in it so they could have babies and tend to the house. Look around. Do you see any passive, submissive women around today? (And you want "tended to?" Just leave the toilet seat up once and she'll give you "tended to!") The point is, that the passive posing of women that was all the rage hundreds of years ago, doesn't really apply to the women of today.

Women want to look like women, of course, but they don't want to look like docile creatures without a thought in their head. I always have this fight with my young photographers (fresh from the local college photography program) about the tilt of the head. They insist that the head of a woman must be tilted in toward the higher

In the era that inspired much of our posing theories of today, women were expected to be passive and submissive.

shoulder. It isn't until I show them how awkward that tilt can make some women look in some poses that they start to understand what I am trying to teach them.

Believe it or not, guys have changed, too. We don't kill our own prey, we shower regularly (well, until the whole "grunge" thing with younger people came along), we help raise our children, and we are allowed to be much less rigid and unemotional. This means you don't have to make every executive portrait of a man look as though he has a stick up his backside. It's alright to have Dad lean forward or recline back slightly. He can even smile a little in a family portrait, so he actually looks like he is enjoying himself.

That said, the first step in learning how to pose today's client is to overlook what you have learned about the clients of yesterday. Notice I said *overlook*, not *forget*. It is important to understand classic posing, but once you understand it, move on. For any of you

Women want to look like women, of course, but they also want to look confident and intelligent.

younger photographers who haven't studied art theory, buy some books, go to some museums, enjoy the beauty in the work of the past and look for ways to improve it for your clients' work in the future.

The Client Knows Best. As you can probably tell from the above, it is usually the photographer's frame of mind, not his or her lack of skill or ability, that becomes the biggest obstacle to creating salable portraits that have a sense of style. Talk to ten photographers on any given subject and every one of them will think that they have the best way of handling the situation. However, we could all bene-fit by keeping in mind that we are in a creative profession and there is not a single "best way." The best way to do something is, quite simply, the way that makes an individual client happy—and what

We are in a creative profession and there is not a single "best way."

The best way to pose your client is the way that makes them happy.

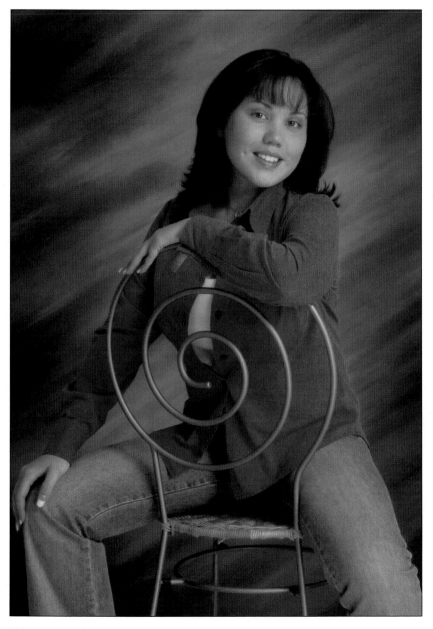

Using sample photographs before the session starts can help you to clearly define the type of portrait and posing the client has in mind.

makes *one* client happy, will not necessarily make *another* client happy.

How to make clients happy is a subject that could easily fill an entire book, but the most effective way to start in that direction is to ask your clients what they want. Using sample photographs before the session starts can help you to clearly define the type of portrait and posing the client has in mind, and this will start you in the right direction.

Talk with each client about the areas of their body and face that they feel they have problems with. And remember, we create a product that is sold on emotions, not need. So even if you don't see a problem with the client, if *they* see one, you will need to address the problem before you will make a sale. When you start finding out these things from your client, you can begin to create portraits that are tailored to *their* tastes, instead of trying to sell them on purchasing portraits that are tailored to *yours*. There will be a big difference in sales and a big difference in how happy the client is with the outcome of the session.

■ Learning Posing

When it comes to posing, many photographers get overwhelmed—like those people who get a new satellite dish with 150 channels and, instead of directing their attention to what's on, start worrying about what *else* is on. As a result, many photographers focus on increasing the number of poses they offer to their clients when they would really be better off improving the quality of these poses and speed at which they direct their clients into them. Once the current poses are mastered and can be repeated easily, then you can look to developing new poses.

For happy clients, focus on the quality of your poses instead of the quantity.

Show, Don't Tell. One of the best learning tools for posing is to show poses to clients by posing yourself first. If you can't demonstrate the pose effectively, you can't direct a client into it. Although we have clients select posing and background styles before their session, I also sit down and go through four to eight different poses that are variations to the pose they selected.

In my studio, the first thing I have young photographers do is learn the poses, then start demonstrating them to clients. At first, they feel very awkward—which is how the client feels. But once they can consistently demonstrate poses and make themselves look good, they have started to master posing.

Update Your Pose Book. After you have demonstrated the pose, watch the client attempt to get into it. Many times, they will not completely repeat what you have shown them, but they will

Add new poses or pose variations to your sample books immediately.

come up with a new variation that is more comfortable for them and that you can add to your pose selections. When this happens, add the new pose or pose variation to your sample books immediately. Photographers often come up with great poses or watch clients go into great posing variations, then forget about them. By taking extra photos for your sample books, you are assured you won't lose your new poses.

■ About This Book

In this book, I have outlined the training I give to the new photographers at my studios. Since there are literally thousands of ways to pose the body, it is overwhelming to memorize each individual pose.

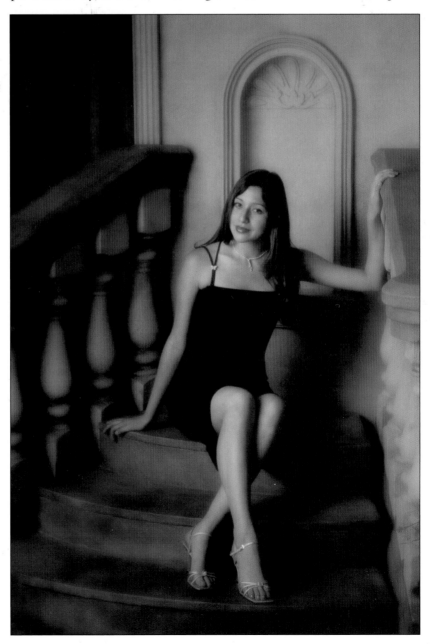

It may feel awkward at first, but the best way to pose clients effectively is to demonstrate the poses yourself.

Effective posing is a much more complex subject than anything else in photography. It takes our photographers much longer to learn than portrait lighting.

If, however, a photographer understands the basics of posing each part of the body, recognizes the problems that are inherent with each part of the body, and then learns to identify the mistakes made by most photographers, it makes the very complex task of posing the human form a learnable process.

Effective posing is a much more complex subject than anything else in photography. Lighting takes our photographers about two years of studying and testing to master, while the same photographers make major errors in posing even four or five years after working daily in the studio.

We will begin our look at posing in a backwards fashion, by looking at what *not* to do—or catching the obvious mistakes made by most photographers. Once you can consistently identify what *not* to do, you can begin to learn what you *should* do to create a salable portrait.

1. SIX THINGS YOU SHOULD NEVER DO

As a photographer starts learning the art of posing, it is much easier to look at posing backwards.

When I hire a new photographer at the studio, they start in the yearbook room. (If you haven't read any of my other books, I have two studios that specialize in senior photography.) For these young, many times overconfident photographers, the task of taking a simple yearbook portrait seems beneath them—that is, until they try to consistently make each of our wide variety of clients look great with only a simple blue cloud background behind them.

At first, this challenge is usually met with an arrogant, "It's just for the yearbook!" At that point, I have to explain to them the importance of that little picture. I usually finish up by noting that if they can't make someone look good in a simple head-and-shoulders pose, they have no chance of making someone look good in the other shooting areas of the studio, where a good portion of the sessions are done full length.

Once their egos are deflated, I can start teaching them posing. As a photographer starts learning the art of posing, it is much easier to look at posing backwards. Instead of trying to learn hundreds of poses and variations on poses for certain circumstances, the best way to start is to look for what I call the "Six Deadly Sins of Posing." If you make sure that a pose doesn't contain these six things, the pose will be salable. The list of things to avoid is as follows:

1. Make sure the face is never turned away from the main light.

2. Make sure the shoulders, waist, and hips are never squared off to the camera.

3. Make sure the arms are never posed in contact with the side of the body.

4. Make sure the chin is never lowered to a point where it diminishes the catchlights in the eyes from the main light.

5. Make sure the spine never forms a vertical line and the shoulders never form a horizontal line in the frame.

6. Make sure to never have an expression on *your* face you don't want on the *client's* face in the portrait.

■ Number One: The Angle of the Face

I, like most photographers, work with a lighting ratio that is approximately 3:1 without diffusion, and 4:1 with diffusion. This means if the face is turned *away* from the light, the shadow on the side of the nose will increase, making the nose appear larger. There are two solutions to this problem: turn the face more toward the main light, or decrease the lighting ratio.

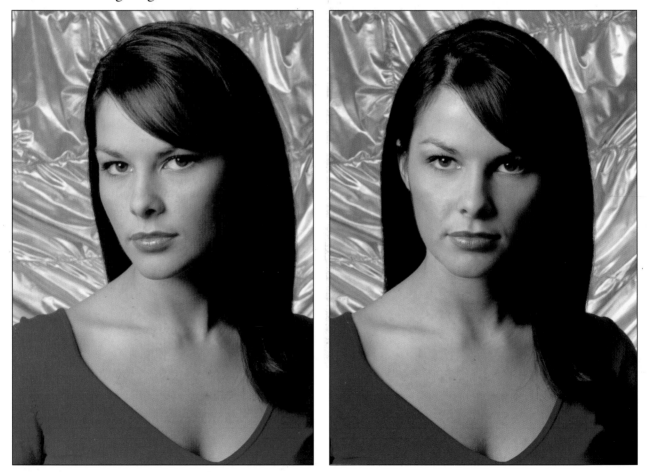

Turning the face toward the main light (left) illuminates the mask of the face and creates shadows that shape it nicely. Turning the face away from the main light (right) creates unflattering shadows.

Decreasing the lighting ratio

produces a flat look

in the portrait.

Decreasing the lighting ratio produces a flat look in the portrait. I call this "mall lighting," because the inexperienced photographers employed by most national and mall photography studios tend to use this very flat lighting to avoid shadows if the face isn't posed properly.

If, instead, you turn the face toward the main light source, whether in the studio or outdoors, you light the mask of the face without increasing shadowing in areas of the face where it shouldn't be. An added bonus: turning the head also stretches out the neck and reduces the appearance of a double chin, if the subject has one.

■ Number Two: The Shoulders, Waist, and Hips

The widest view of any person is when the person is squared off to the camera. By turning the shoulders, waist, and hips to a side view, preferably toward the shadow side of the frame, you create the thinnest view of the body—and we all want to look as thin as possible.

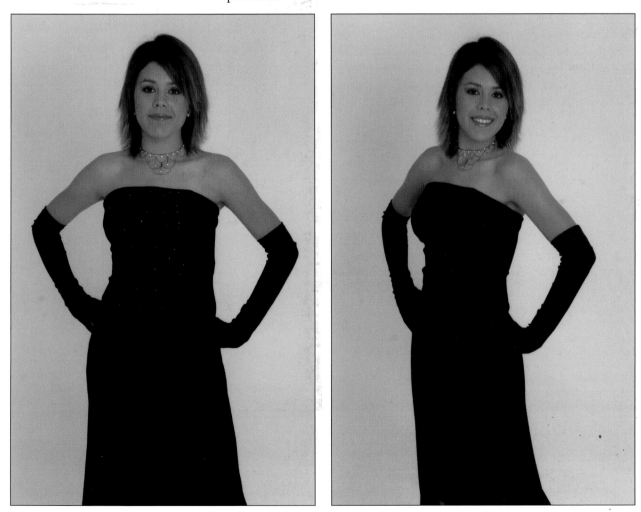

When the hips and shoulders are square to the camera (left), the body looks wide. Turning the body to an angled view (right) is much more flattering to the figure.

■ Number Three: The Arms

When the arms are allowed to hang down to the side of a client, the body isn't defined. It is one mass, making the body appear wider. When the elbows are away from the body, the waistline is defined and appears smaller.

Keeping the arms away from the side of the body makes the waist look slimmer.

■ Number Four: Lower the Chin, Lose the Catchlights

Having no catchlights in the eyes is a problem I see in images by both young photographers and more seasoned ones. This comes from the knowledge that lowering the chin produces a more attractive angle of the face, but being too lazy to lower the main light to compensate for the pose.

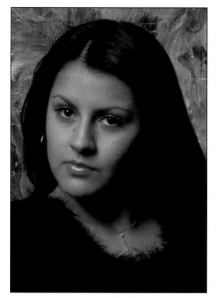

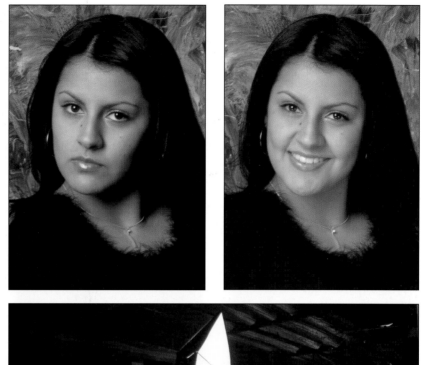

Adjust the lighting each time you pose your client. Raise the main light to a point that is obviously too high, as shown in the top left photo, which has heavy shadows under the eyes and nose, a dark shadow on the side of the face, and diminished catchlights. Slowly lower the light until the effect is what you are looking for (top center). To complete the lighting, add the reflector underneath the subject bouncing light up onto the face (top right). To the right, the setup for this image.

Strong catchlights in the eyes are the single most important aspect of a portrait (from a lighting standpoint). The main light should be adjusted with each client, in each pose, to ensure the proper placement. I tell our young photographers to elevate the main light to a point where it is obviously too high (with no apparent catchlight) and then slowly lower it until the proper lighting effect is achieved. This forces them to adjust the light with each pose and ensures that each client will have catchlights in each one of their poses.

■ Number Five: The Spine and Shoulders

This could be called the "anti-stiffness" rule. When you see a portrait of a person in which their shoulders are running perfectly horizontal through the frame, or in which the spine (if you could see it)

is running perfectly vertical in the frame, the person in the portrait appears stiff. Visually, you are telling everyone who sees this portrait that your client is uptight and very rigid.

By posing the person reclining slightly backwards or leaning slightly forward, the shoulders and spine go diagonally through the frame and achieve a more relaxed look. The portrait will have a professional look and it will be more visually appealing.It will also create a more flattering impression of the subject's personality.

■ Number Six: Your Expression

This is by far the most important of the rules. The first "photography saying" I heard was "expression sells photographs"—and it's true! You can have the perfect pose and the perfect lighting, but if the expression doesn't meet the client's expectations, you won't sell the portrait.

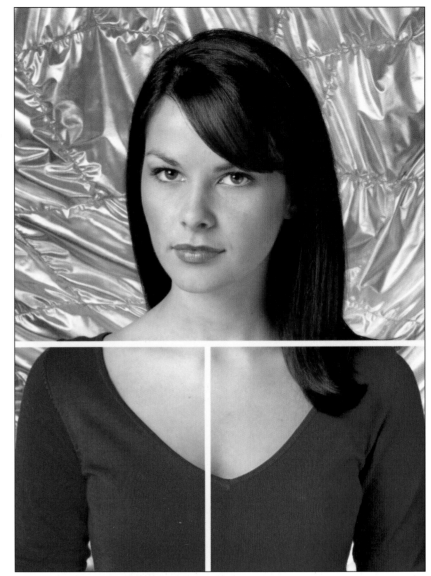

Again, this is another area where photographers think they know best. Most photographers like serious expressions with the lips together or glamorous expressions with the lips slightly separated. Among the public, however, mothers are the dominant buyers of professional photography, and they like smiles. Women tend to be the decision makers about photography, and they generally like portraits where the subjects (whether it's their kids, their parents, or their neighbors) look happy. Happy sells—and if you want to profit from your work, you had better produce what sells.

Many photographers have a problem getting a subject to achieve a pleasant expression. Most of the time the problem comes from the photographer not realizing an important concept called "mirror-

ing." When you smile at a person, they smile back, and when you frown at a person, they immediately frown back. People will mirror the expression that you, as the photographer, have on your face.

Our attitudes and outlooks on life set our expressions, and sometimes this gets in the way of making our clients look their best. We had one photographer with us a few years back who smiled all the time. He was great at getting clients to smile, but he would frustrate clients when it came to creating nonsmiling poses. He would tell the client to have a relaxed expression (nonsmiling), while he still had a huge grin on his face. Many clients would get mad and ask how they were supposed to be serious while they were looking at his big goofy smile.

A photographer we had before that couldn't smile to save his life. He would look at the client with a deadpan expression and, with a monotone voice, say, "Okay, smile big now." As you can imagine, the clients' expressions suffered as a result.

Mirroring isn't just about visual cues like your expression, it also involves the way you speak. When you are looking at the client with

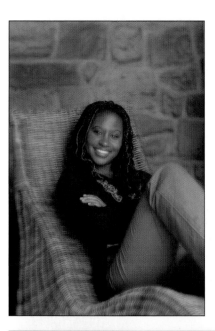

Subjects will mirror your expression, so if you want a natural smile on your client's face, you need to have one on yours.

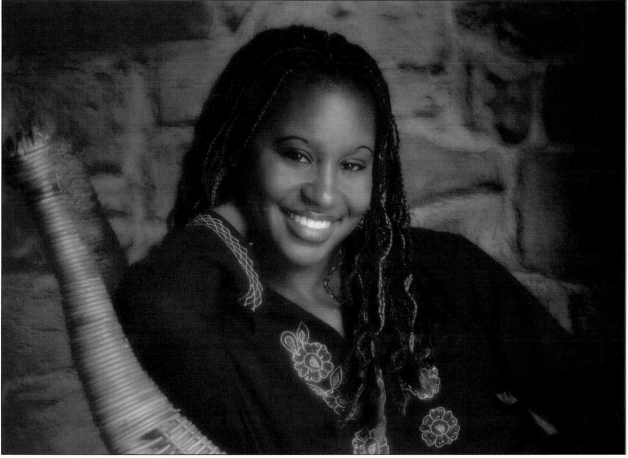

a smile on your face, speak with energy and excitement in your voice. When you want a relaxed expression, soften your voice. In this way, you are in control of every client's expression. Understand the expression your client wants, then take control and make sure that you take the majority of poses with that expression.

When you want a smile on the subject's face, you should smile and speak in an upbeat voice (left). When you want a more serious expression, use a more subdued voice and don't smile (right).

Although many of these rules are basic for some photographers, we have to start somewhere. Posing is a study of the human form that never ends, because it is a study that is always changing. From my experience, the photographers that have the hardest time with creating posing that meets clients' expectations are the young photographers and the older, "well seasoned" photographers. Both tend to pose a client to meet their own expectations and not the client's. If you pose clients in this way, they will never be as happy as they could be, and you will never profit as much as you could by learning to pose for the client and not yourself.

■ An Additional Factor: The Tilt of the Head

The tilt of the head isn't listed under the six deadly sins, because 90 percent of the time when you have the client turn their head toward the main light, the angle of the head will be close to the correct position. Typically, the client's head is in a comfortable position at this point, and much closer to the correct position than I have seen my

young photographers get the head when they re-pose it after the client's face is turned.

The only time the head needs to be repositioned is when the client is extremely nervous. Then you will find that the top of the head slowly starts tilting toward the higher shoulder. Photographers fresh from photography school think this is a good thing, but it is not. The head naturally tilts toward the higher shoulder because the client feels awkward and uneasy. Their body is trying to tell you something. Think about it—if people tend to pose this way because they feel awkward or nervous, then why on earth would you pose someone this way *on purpose*?! We will discuss the tilt further in chapter 3.

There you have it. If you make sure that each pose doesn't include the six deadly sins, you will have salable photographs. The trick is reminding yourself to check every pose before you take the first image. Once you start recognizing what not to do, you can start to learn what you should do. For our young photographers, learning posing in this backwards manner seems odd, but it gets them into the game quickly, rather than making them struggle for years.

By making sure that your image doesn't include one of the six deadly sins of posing, you can ensure that you are creating a salable photograph.

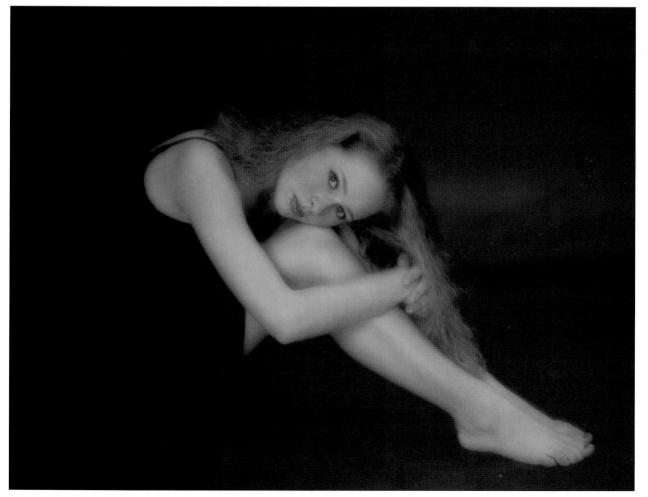

2. DEFINING THE POSE

*A*s you get beyond basic posing, you will first need to identify the reason the client wants the portrait taken. Imagine that a young woman comes to your studio for a session. All you know is she wants a portrait of herself. Without finding out the purpose of the portrait, you are shooting in the dark. She might want a business portrait, a portrait for her husband or boyfriend, or an image for her parents or grandparents.

The posing of a portrait that is to be given to a parent would be much different than a portrait that would be given to a husband or boyfriend. A business portrait would be taken with a different look than a portrait that reflected the person as she is in her "off-duty" hours. Although there are many reasons why a portrait might be taken, most photographers approach the posing of a client in the exact same way, no matter what the purpose of the portrait.

Without finding out the purpose of the portrait, you are shooting in the dark.

■ Types of Poses

Once you find out the purpose of the portrait, then you need to select a posing style that will be appropriate for the final portrait. Basically there are four posing styles to work with: traditional posing, casual posing, journalistic posing, and glamorous posing. Within a single person's session you may use a variety of posing styles. This is a business decision you must make. But to learn posing you need to be able to distinguish between the various types of posing and know what type of situation each is suited for.

Traditional Posing. Traditional posing is used for portraits for business, yearbooks, people of power, and people of distinction.

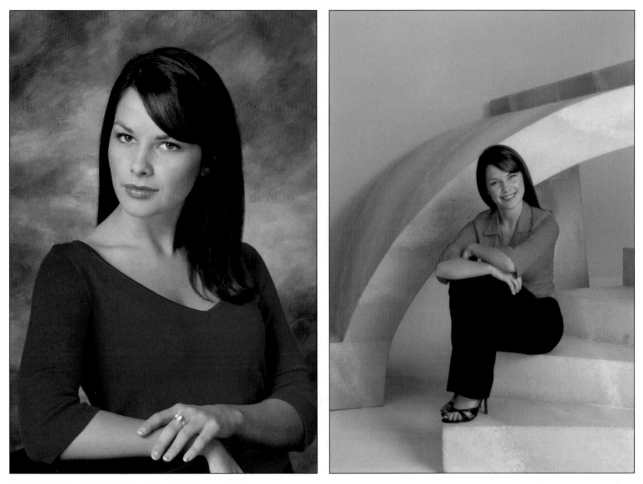

Classic posing reflects power and elegance. The posing is understated, and the expression is more subdued.

Whether the client is a judge,

a businessperson, or a priest,

the posing needs to be subtle.

This style of posing reflects power, and to some degree wealth, respect, and a classic elegance. Whether these portraits are taken in a head-and-shoulders- or full-length style, the posing is more linear, with only slight changes in the angles of the body.

Whether the client is a judge, a businessperson, or a priest, the posing needs to be subtle. Most of the time, these clients will feel more comfortable in a standing rather than a seated position—mostly because of the clothing they are in. Still, the subject's arms shouldn't rest on the side of the body. An elbow can rest on a chair or other posing aid, or the hands can be put into the pockets, but not so deep as to have the arms against the side of the body.

The expressions should be more subtle as well. Laughing smiles are definitely not appropriate. But at the same time, serious expressions need to be relaxed. Most people taking traditional portraits aren't comfortable doing so, and therefore have a tendency to scowl—and this needs to be avoided.

Casual Posing. Casual posing is a style of posing in which the body is basically positioned as it would be when we are relaxing. Watching people as they are watching TV, talking on the phone, or on a picnic, and you will see the most natural and best casual poses

for your clients. Casual poses are used when the portrait is to be given to a loved one, like a sibling or parent.

Casual poses are resting poses. The arms rest on the legs, the chin rests on the hands. The back is posed at more of an angle. It is common to use the ground to pose on, laying back on the side or even on the stomach. The purpose is to capture people as they really are.

Casual poses are used when you want to photograph your subjects as they really are.

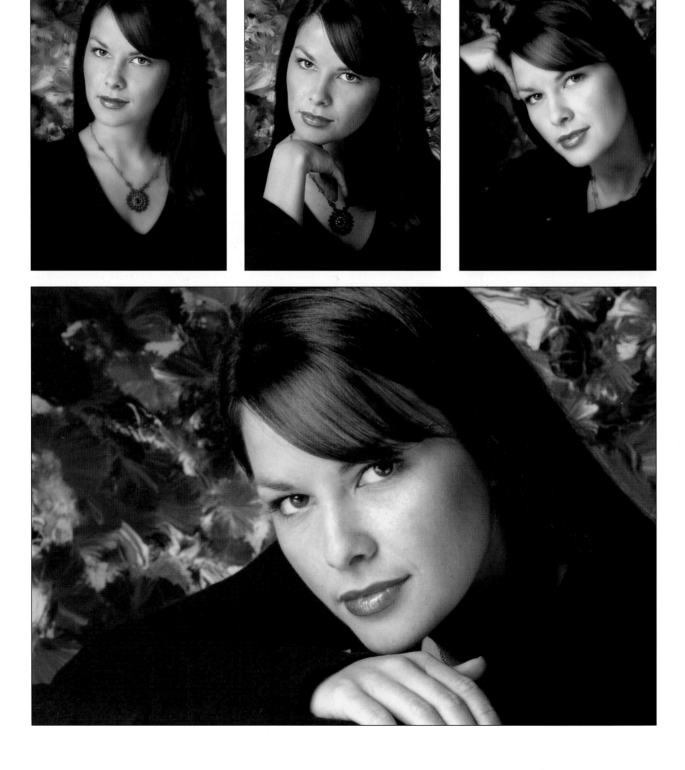

Journalistic Posing. Journalistic posing really isn't posing at all. It is recording people as they interact with their environment. It is capturing the child, bride, or family in an activity so they basically forget you are are recording their image. This type of portrait is a very specific type and not one that the majority of people will respond to when it comes time to purchase, unless they have requested it and have a complete understanding of what the outcome of the session will look like.

Glamourous Posing. Glamourous posing is posing that is taken to achieve what people commonly call "the look." Call it sensual or sexy, it is posing that makes the subject look as appealing and attractive as possible. I am not talking about boudoir or the type of glamour that achieves its look by having the client in little or no clothing. You can pose a fully clothed human being in certain ways and make them look extremely glamourous and appealing. If you finish the pose with the right expression, often with the lips slightly parted, you will have made the client's romantic interest very happy.

An excellent source of glamourous posing is found in catalogs such as those published by Victoria's Secret or Frederick's of

Glamorous posing is designed to make the subject look sensual and alluring.

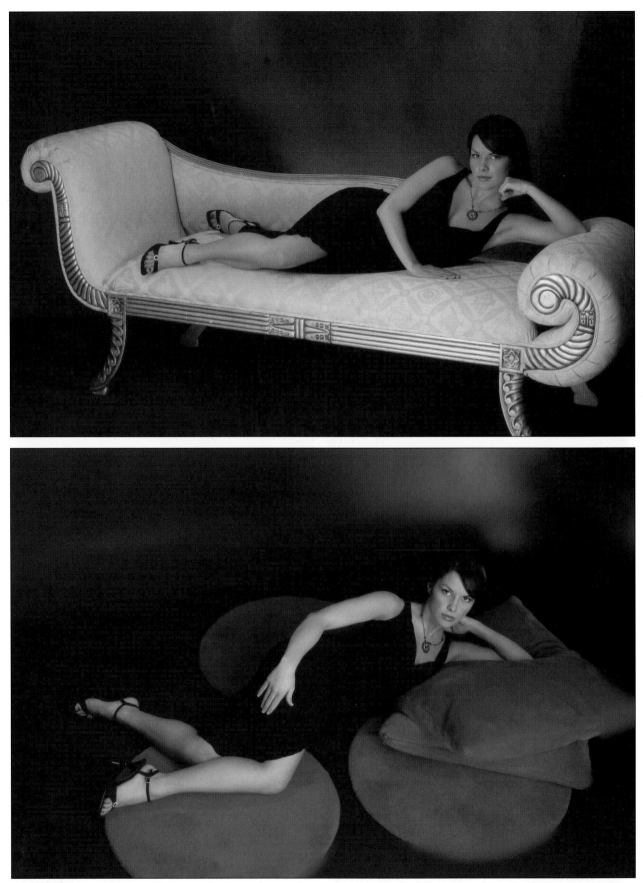

Glamorous posing makes the subject look as attractive as possible. It's the type of posing you'd probably want to use when the subject wants a portrait for their significant other.

Hollywood. The photographers who create these images are masters of making the human form look good to the opposite sex. Your client will just have more clothing on.

The purpose of defining each type of posing, as well as determining the reason the portrait is being taken, is to have a direction for the session. This is the point at which a photographer's own style and experience take over. For example, many of my traditional poses are much more glamourous in their look than what the average photographer would consider traditional. This is because, as human beings, I think we all want to appear attractive. People who say they don't care how they look are the same people who say they don't care about money—and I think that people who would say things like *that* would lie about other things, too!

■ Settings, Clothing, and Posing

Selecting the right clothing and setting goes hand in hand with posing; it is only when the right pose is combined with the proper clothing, in the proper setting, and with the appropriate expression, that the portrait attains a sense of style. Only when everything in a portrait makes sense visually do you achieve a portrait that really works. Achieving this requires that you look at every aspect of the portrait and match each element to the others.

Different portrait settings require different styles of clothing and posing to appear well coordinated.

The style of clothing is very easy to start with. Most photographers, no matter how fashion-impaired they are, can tell the difference between casual clothing, business clothing, and elegant clothing. This clothing needs to be paired with a setting or scene that reflects the same style.

Settings. The predominant lines and textures in a scene or background are what visually communicate its overall feeling, so be sure to evaluate these carefully. Studying art theory will help you determine what feeling these lines and textures communicate.

In the studio, a background that has strong linear lines communicates a sense of structure and strength, while backgrounds that

Sets with curved lines have a softer, more artistic look that often suits a more formal style of dress and pose.

Sets with straight lines have an stronger, more assertive look that often suits a more casual style of dress and pose.

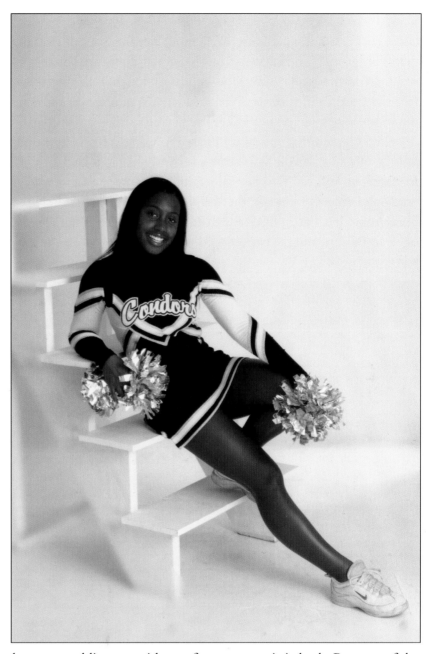

This does not mean that you should only use "feminine" backgrounds when creating portraits of female subjects.

have curved lines provide a softer, more artistic look. Because of the traditional associations, linear backgrounds are often considered more masculine, while ones with curved lines tend to be considered more feminine. For example, think of the columns commonly used as set elements by photographers. Rounded columns would be considered more feminine, while squared columns would be considered more masculine.

This does not, however, mean that you should only use "feminine" backgrounds when creating portraits of female subjects. As noted previously, many of the traditional ideas about what's feminine and what's masculine just don't apply to today's clients and their tastes. Plus, there are factors beyond gender that must be con-

sidered when selecting a backdrop. For example, you will find that cloud backgrounds work better with more elegant types of clothing than backgrounds that have strong diagonal lines. Diagonal lines work well with casual clothing. As you begin looking for the feeling that the backgrounds convey, you will start to pick up on the ways the various lines and textures alter the feeling of the background.

Keep in mind that you aren't limited to using your backgrounds in only one way. If you have strong vertical lines in a background, for example, you can tilt your camera to make the lines more diagonal—and this will change the feeling of the background. If the background has a great deal of texture but you need a softer feeling, open up the lens and the background will soften to produce the look you want.

When the background has a lot of detail, letting it fall out of focus will help keep the attention on your subject.

When you go outdoors, it becomes much easier to read the feeling a scene portrays. Coordinating the clothing and posing to the scene to achieve an overall scene of style becomes easier. A typical park or garden scene is a more casual setting, therefore more casual clothing and posing is required. An outdoor setting with columns and fountains is obviously more elegant and requires more elegant clothing. To achieve a sense of style and to visually make sense, you wouldn't put a woman in an elegant dress in the middle of what

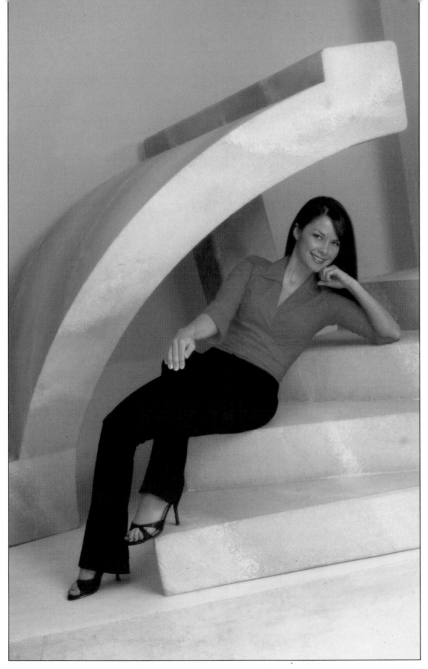

Tilting the cameras will turn strong horizontal or vertical lines into softer diagonal ones.

looks like a forest, nor would you put a girl in overalls in a scene that appears to be the outside of a castle.

Taking Your Clue from Clothing. Clothing is an excellent clue as to the type of posing that should be used. With seniors, in one session you go from shorts and summer tops to a prom dress. Primarily, the clothing sets the look for the portrait—a look that the posing needs to reflect to create an image with a sense of style.

You can select the clothing to match the type of posing you want to use, or you can match the posing to the client's choice of clothing. However, you and the client need to realize that the best type of posing is determined by the clothing. When a young lady walks out of the dressing room in a pair of shorts, barefoot, and with a summery top on, it doesn't take a rocket scientist to figure out you will be using casual posing. When the a girl comes out in a prom dress, again, it isn't difficult to select glamourous posing to suit the dress. Of course, you can also decide to use a style of posing that isn't the obvious choice, but you need to make sure that everything in the portrait comes together to visually make sense.

In the upcoming chapters, we will look at the various parts of the body and the best ways to pose them to make them look their best. Remember that the overall look of the entire pose will be determined by how you pose the individual parts of the body. A good pose positions each part of the body effectively to achieve the desired look. Basically, it is each part of the body, as well as the sum of the parts, that makes a pose work or not.

You can think of this like posing a group. If you are familiar with the old posing charts that used to be employed to suggest posing for family groups, you know that they only explained where to put each

body within the composition of the frame. They did not, however, show how to make each person within the group look good individually and as a piece of the whole composition. This should be the standard you use to judge your success: whether it is a single body or a group of bodies, each part must look good both individually *and* as an element of the overall image. In this way, you will achieve the look the client wants.

■ Capturing the "Real" Person

Working with seniors, as we do, 90 percent of all the portraits we take are casual poses. Seniors and parents typically want portraits that capture the "real" them. Many photographers entering this market may find this hard to believe, considering all the senior photographers who show samples that would be classified as glamourous posing and feature seniors in swimwear, push-up crop tops, and the like.

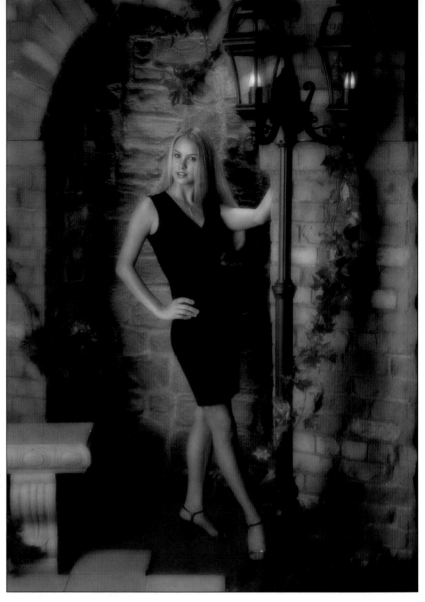

Each part of the body must look good both individually and as an element of the overall image. In this way, you will achieve the look the client wants.

While some photographers might enjoy taking and looking at portraits done in such a way, parents are unlikely to spend their money on portraits that make their seventeen-year-old daughter look like she belongs on a men's calendar. In almost twenty years of photographing seniors, I have had only three young ladies that wanted to be photographed in swimwear. Two were at the request of the mothers and one was for a pageant. As you can see, this type of portrait doesn't exactly generate big business.

The desire of our clients to capture the "real" person is the reason why we always have clients select the poses and backgrounds that most impress them in the sample books. This way the client selects what is right for them. We also ask clients to bring in clippings from magazines that show posing they like. These are ideas that are handpicked by your target audience—which is much better than getting ideas from photographers who are trying to fill seats at a seminar instead of showing the less exciting ideas that actually sell.

3. POSING THE FACE

We will start off with the face, because the face is the most important part of any portrait. There are portraits created by photographers that have the face in silhouette or obscured from view in one form or another, but this is usually an artistic exercise for the photographer, not a portrait that would be salable to the average client.

■ The Connection to Lighting

In the same way that the posing of the body is linked to clothing, the posing of the face is linked to lighting. Posing that will work with soft lighting and a low lighting ratio will look ridiculous with a harder light source or a high lighting ratio.

Light from Below. As previously noted, my lighting has more of a glamour/fashion look than most traditional portrait lighting. For example, I like to have a light come from underneath the subject, whether it is for a head-and-shoulders-, three-quarter-, or full-length portrait. For everything up to three-quarter-length poses, we use a trifold reflector to create this light; for full-length poses, this reflector is replaced by a light on the floor in order to achieve the same lighting effect.

This light coming from underneath the subject adds an additional catchlight in the eyes, brings out more of the eye color, reduces the darkness under the eyes that most people have, and smooths the complexion. For our images of seniors, it has worked out very well. Because my clients are younger, they like the more fashionable look of this lighting.

This light coming from underneath the subject adds an additional catchlight in the eyes . . .

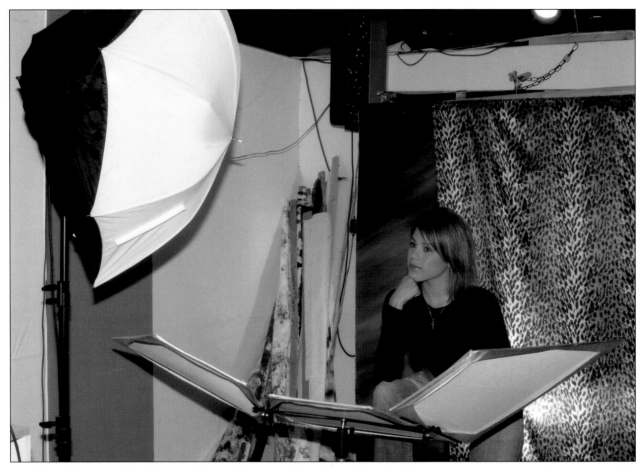

Consistency. Consistency is another consideration when looking at the correlation between lighting and posing. We use a 42-inch light box for our head-and-shoulders shooting areas, a 52-inch box where we take most of our three-quarter-length poses, and a 72-inch Starfish (or 7-foot Octabox) for the areas where we take our full-length poses. The 72-inch box is used for small sets and scenes, while the 7-foot Octabox is used for the more elaborate sets.

Hardness or Softness of the Source. I realize that this is basic lighting theory, but the two factors that determine how soft or hard a light is (and therefore the posing that can be used) are the size of the light source and the distance between the light source and the subject. The reason we use smaller boxes in the head-and-shoulders areas and huge boxes in the full-length areas of the studio is that they are proportionately the same size when you consider the distance between the light sources and the subject.

Just to make sure we're all on the same page before we proceed, I'll explain—I don't want anyone to be confused. A 40-inch box that is placed four feet away from the subject will give you approximately the same quality of light (contrast, size of catchlights in the eyes, density of shadow, etc.) as a 72-inch soft box placed six to seven feet away from the subject or a 7-foot box at eight to nine feet

For more of a glamour/fashion look, I like to have a light come from underneath the subject.

Consistency is another consideration when looking at the correlation between lighting and posing.

from the subject. Now, I'm sure I'm going to get an e-mail from a math wizard who wants to explain that my calculations were off. This isn't rocket science, and I am not using a calculator to precisely apply the inverse-square law, but it's close. It provides a consistent appearance in our lighting throughout the entire studio.

Unfortunately, in many studios, a single light box is used for all types of portraits. This means that the light on the head-and-shoulders portraits has a different quality (contrast, size of catchlight in the eyes, density of shadow, etc.) than the light on the full-length poses. These variations in lighting require the photographer to come up with variations in posing. For example, as the main light is pulled back farther from the subject (reducing its apparent size) it will

Unfortunately, in many studios, a single light box is used for all types of portraits.

Maintaining a consistent quality of light when moving from head-and-shoulders portraits to full-length ones requires the use of progressively larger light sources.

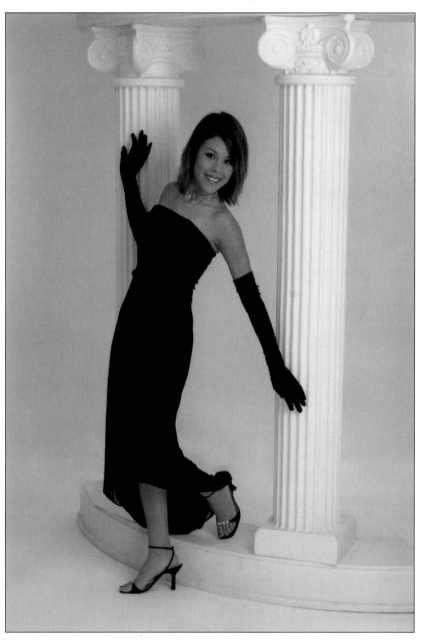

increase in contrast. As a result, the shadow on the side of the nose will increase, and this will need to be reduced by turning the subject's face more toward the main light.

■ The Eyes

Catchlights. The eyes are the windows to the soul and the focal point for any portrait. You can create the most stunning pose in the

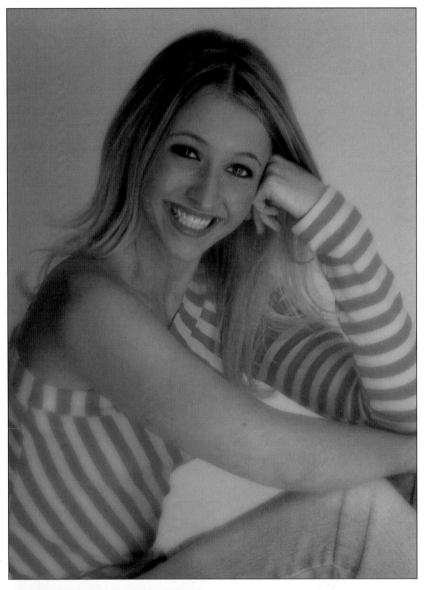

The eyes are the windows

to the soul and the focal point

for any portrait.

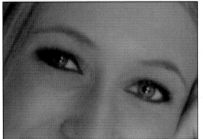

Light from underneath the subject adds an additional catchlight in the eyes (see left) and brings out more of the eye color.

Catchlights attract the viewer of the portrait to the eyes and are one of the primary goals of any professional photographer.

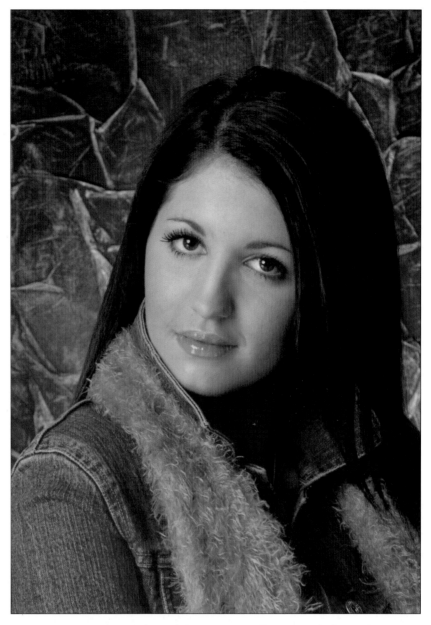

The single biggest mistake

photographers make outdoors

is not having distinct

catchlights in the eyes.

most stunning scene, but if the eyes are not properly lit and properly posed, the portrait will not be salable. The eyes give life to the portrait, and it is particularly the catchlights that give the eyes life. They attract the viewer of the portrait to the eyes and are one of the primary goals of any professional photographer.

In my book *Outdoor and Location Photography* (Amherst Media, 2002), I stated that the single biggest mistake photographers make outdoors is not having distinct catchlights in the eyes. The same is true for inexperienced photographers in the studio. They don't check the eyes with each and every portrait they take.

Most photographers don't really think about posing the eyes. They look at the face as a whole, but, again, it is each part as well as *the sum* of the parts that make a good pose. A good working strate-

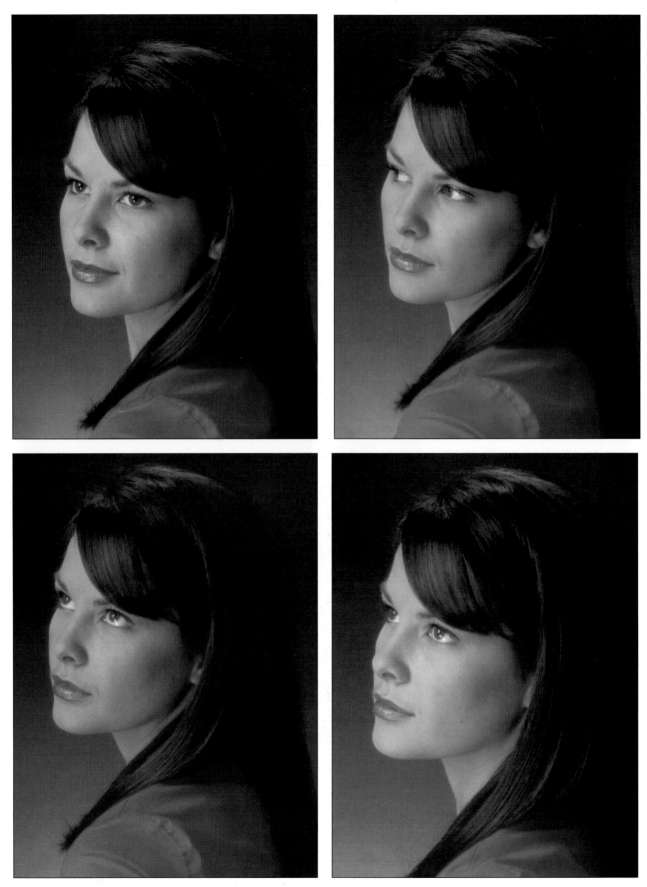

Changing the direction of the subject's gaze dramatically alters the feel of a portrait—and sometimes not in flattering ways.

gy is to pose the eyes (which would of course include the face) and then adjust the lighting to the pose.

Position of the Eyes. There are two ways to control the position of the eyes in a portrait. First, you can change the pose of the eyes by turning the subject's face. Second, you can have the subject change the direction of their eyes to look higher, lower, or to one side of the camera.

Typically, the center of the eye is positioned toward the corner of the eye opening. This enlarges the appearance of the eye and gives the eye more impact. This is achieved by turning the face toward the main light while the eyes come back to the camera. This works well

This enlarges the appearance of the eye and gives the eye more impact.

The point at which you ask the subject to focus their gaze in respect to the position of the camera's lens also, in essence, poses the eye.

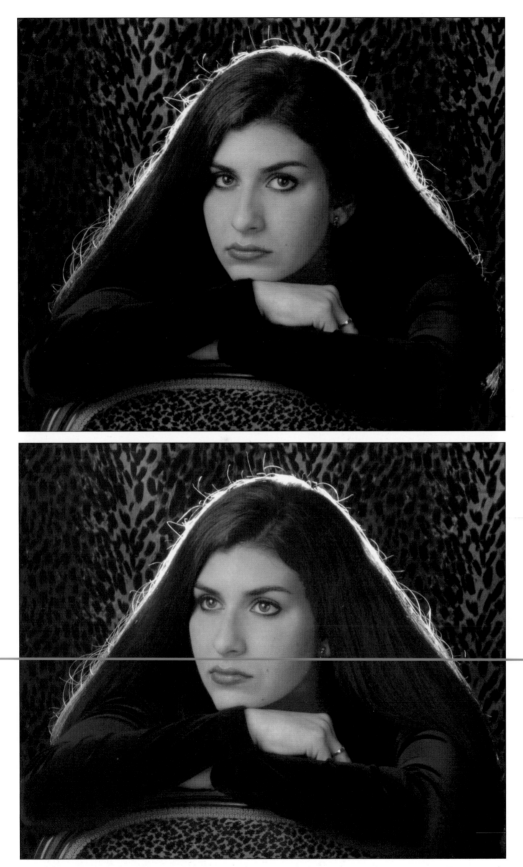

Most of our clients prefer the intimate feeling of eye contact, but portraits with the subject looking off-camera can also have a nice, pensive look.

for all shapes of eyes, except for people with bulging eyes. When this is done on bulging eyes, too much of the white will show and draw attention to the problem.

Eye Contact. The point at which you ask the subject to focus their gaze in respect to the position of the camera's lens also, in essence, poses the eye. First and foremost, the subject should always be looking at some*one*, not some*thing*. To do this, I put my face where I want their eyes to be. There is a certain spark that the eyes have when they look into someone else's eyes that they don't have when they are looking at a spot on the wall or a camera lens.

Usually, I position my face directly over the camera. This puts the eyes in a slightly upward position, increasing the appearance of

There is a certain spark that the eyes have when they look into someone else's eyes . . .

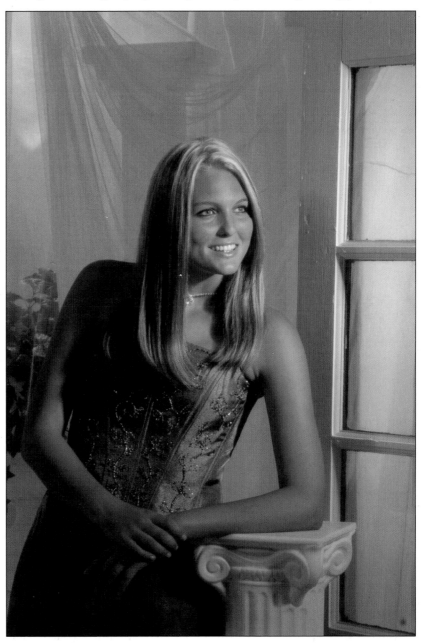

Even when the subject is looking off-camera, they should have a person to look at; otherwise their eyes may not look engaged.

the catchlights. If the camera position is too high to make this possible, I position my face on the main-light side of the camera, never beneath it and never to the shadow side of it. Both would decrease the catchlights.

With my face directly to the side the camera, the eyes appear to be looking directly into the lens, even though the subject is actually looking at me. When looking from the side of the camera, a common mistake that my new photographers make is getting their face too far from the camera. This makes the eyes of the subject appear to be looking off-camera—which is fine if that is the intention and not a mistake.

A common mistake that my new photographers make is getting their face too far from the camera.

Usually, I position my face directly over the camera and have the subject make eye contact with me. This puts the eyes in a slightly upward position, increasing the appearance of the catchlights.

The eyes are the focal point of every portrait, so they must be attractively posed and appealingly lit.

When the eyes of the subject look into the lens, the portrait seems to make eye contact with the viewer.

When the eyes of the subject look into the lens (or very close to it), the portrait seems to make eye contact with the viewer. This type of portrait typically sells better than portraits that have the subject looking off-camera in a more reflective pose. Reflective posing does, however, work in a storytelling portrait—a bride glancing out a window as if waiting for her groom, a senior glancing over the top of a book and thinking of the future, new parents looking down at their baby and thinking of how many diapers they are going to have to change before that kid is potty trained. Well, maybe not that last one—but you get the picture.

An overwhelming majority of our senior clients prefer the intimate feeling of eye contact as opposed to the more reflective portraits where the eyes look off-camera, but this is *our* clients. You need to offer both styles of portraits and discuss with *your* clients what is right for them.

■ Reflective Poses and Profiles

If the eyes are to look away from the camera, there a few rules that need to be followed. They are really simple rules, but ones that I see broken often.

Eyes Follow the Nose. First of all, the eyes should follow the same line as that of the nose. It looks ridiculous to have the eyes looking in a different direction than the nose is pointing. This goes for poses with the subject looking just off-camera, as well as for complete profiles.

One Eye or Two. As you turn the face away from the camera, there comes a point where the bridge of the nose starts to obscure the eye farthest from the camera. At this point, you have gone too far. Either you go into a complete profile, showing only one eye, or you bring the face back to provide a clear view of both eyes.

Lighting. Another common mistake with this type of posing is with the lighting. Many photographers don't move their main light as they rotate the subject away from the camera. However, your main light should remain at a consistent angle to the subject as you turn the subject toward the profile position. If you normally work with the main light at a 45- to 50-degree angle to the subject's nose, the main light should stay at that same angle relative to the nose as you rotate the face away from the camera. This keeps the lighting consistent and doesn't destroy the shadowing on the face.

Many photographers don't move their main light as they rotate the subject away from the camera.

■ The Tilt

How I wish that every college teaching photography would just avoid this one subject. I have never seen one aspect of photography that so many photographers leave school doing so badly. I have seen everything from young ladies who look completely awkward, to guys who look like they were just involved in a car crash that broke their neck.

The Traditional Rules. While many college students will accept that there are different ways to light, pose, and photograph a subject, a lot of them are convinced that there is only one way to tilt the head of each gender—and it's precisely the way their teacher told them! I have had some truly talented photographers work for me, and that is the one obstacle I have had to overcome with almost every one of them.

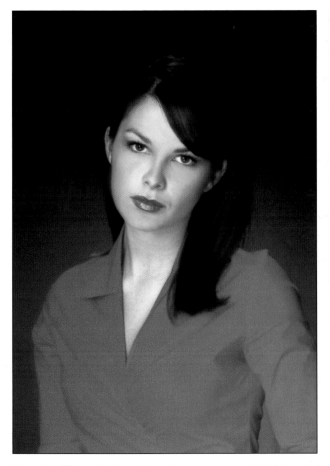

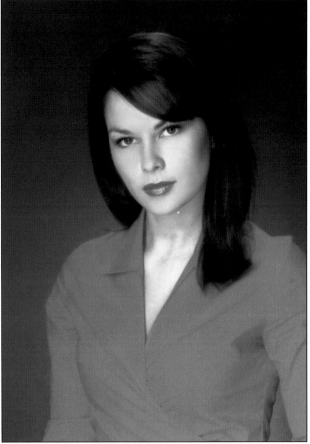

The only difference between these two portraits is the tilt of the subject's head—but what a difference it makes!

When photographing a woman with long hair, I look to the hair and not the gender to decide the direction the head will be tilted.

Which of the above photographs do you like better? If you are like all the people I showed these photographs to, you would say the one on the right. Well there goes the classic theory of posing shot right in the keister. According to that theory, a woman is always supposed to tilt her head toward her higher shoulder. Well, in these two images, tilting the head toward the high shoulder makes her look as though she just sat on a very sharp object and is waiting until we take the picture to get the heck off of it. By tilting the head into what traditionalists consider a "man's" pose, we made her look confident, beautiful, and nothing like a man.

The Real Rule. Now that I have had a little fun, I can continue. The real rule of tilting the head is that there is no rule. You don't *always* do *anything* in photography—especially nowadays. If you are photographing a woman, you don't tilt toward the high shoulder and you don't tilt toward the low shoulder, you tilt toward the shoulder that looks good.

Hair. When photographing a woman with long hair, I look to the hair and not the gender to decide the direction the head will be tilted and the direction in which the body will be placed. Long hair is beautiful, and there must be an empty space to put it. A woman's hair is usually thicker on one side of her head than the other. The

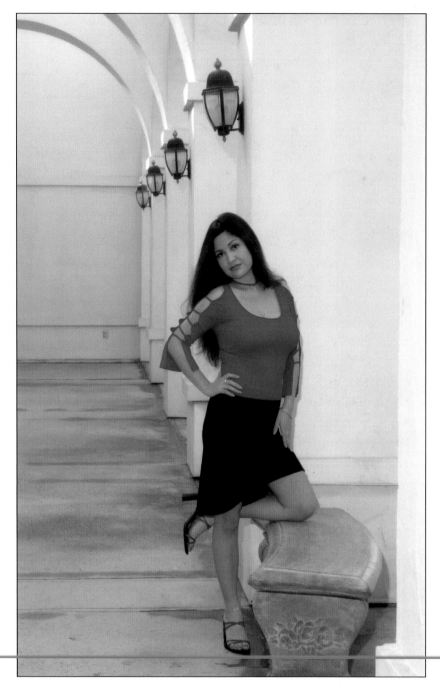

For women with long hair, tilting the head toward the hair's thicker side creates an area for it to be displayed.

tilt will go to the fuller side of the hair and the pose will create a void on the same side for it to drape into. This means she will sometimes be tilting toward the lower shoulder.

Guys. Guys typically aren't gender benders when it comes to posing. They usually need the classic tilt. Society has taken away their manhood; the tilt is all they have left—just kidding! However, men typically *do* look better tilting the head toward the lower shoulder, or not tilting at all. But again, the pose and the circumstance dictate the direction the head is tilted or whether it is not tilted at all.

Guys typically aren't gender

benders when it comes to posing.

The easiest way to learn about the head tilt is to first pose the body. Then, turn the face to achieve the perfect lighting and look. Then stop. If the person looks great (as about 80 percent of clients do), take the image. If the subject is very uncomfortable and starts tilting their head in an awkward direction, correct it. It's that simple.

■ The Neck

The neck really isn't posed and it really isn't part of the face, but there are a few points that should be shared about this area. First of all, the neck is the first to show weight gain and age. In many clients, as you turn the face toward the light, the little cord-like tendons pop out, making the subject look like Jim Carrey doing his Fire Marshall Bob routine on *In Living Color* (if you don't happen to be familiar with the character, then trust me—it's not an appealing or flattering look). The best way to handle the neck area is to cover it up with clothing. If this isn't possible, use a pose that obscures this area from view.

If it isn't possible to either conceal or obscure a problematic neck area, then you just have to deal with it. If the tendons begin to show, have the subject turn their face back toward the camera and reposition your lighting. If loose skin or weight gain make this area

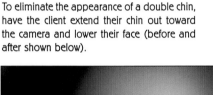

If the subject is uncomfortable and starts tilting their head in an awkward direction, correct it.

To eliminate the appearance of a double chin, have the client extend their chin out toward the camera and lower their face (before and after shown below).

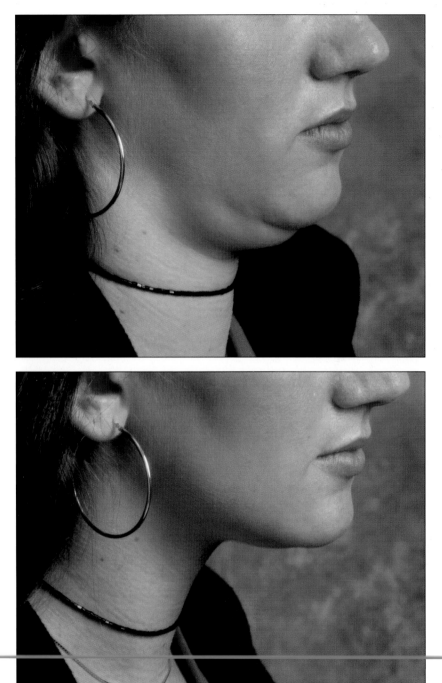

Here seen from the side, the "turkey neck" pose helps stretch out the area under the chin for a more flattering appearance.

a problem, have the client extend their chin out to the camera and then lower their face, basically bowing their neck (which is why this pose is commonly referred to as the "turkey neck").

The face and neck are by far the most important areas to deal with in a pose, for they appear in every portrait you create. In the next chapter, we will move farther down the body, talking about the shoulders, arms, and hands.

4. POSING THE SHOULDERS, ARMS, AND HANDS

Posing isn't just about the body, it's also about the clothes, lighting, and set.

Posing the human body is more involved than just learning some ways to configure the limbs. To understand how to pose a subject you must understand how the pose works with other aspects of the photographic process to achieve the

desired look or style. As we discussed in the previous chapters, the posing of the body must be coordinated with the clothing, and to effectively pose the face you must consider the style of lighting.

In posing the arms and shoulders, your posing must not only make the person look their best and achieve the desired look, but both the arms and shoulders must be placed to enhance the composition of the portrait. As important as it is to position the arms away from the body to define the waistline, it is equally important to do what I call "finishing off the frame."

◼ Triangular Composition

"Finishing off the frame" is a phrase I use when I am trying to teach composition to young yearbook photographers. After they start to understand the basics of posing (and the six deadly sins), I show them how to finish off the bottom of the frame.

In a yearbook pose, the composition of a portrait looks finished if the shoulders fill the bottom of the frame from one side to the

A composition looks finished when the head is at the peak of a triangle formed by the shoulders and the rest of the body.

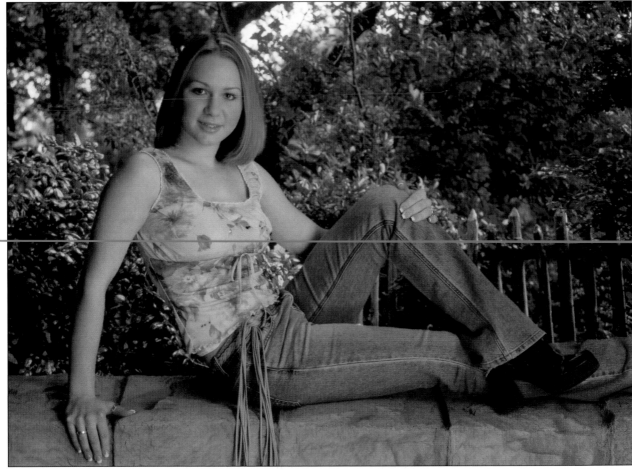

In this pose, you can see how the subject's bent leg forms the base of a triangle, leading your eyes up to her face at the peak.

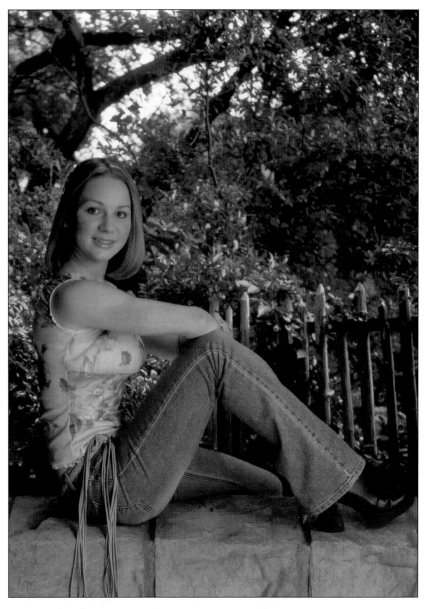

Look for the bottom of the triangle

and crop the portrait there.

other. If the portrait is composed showing more of the body, then the arms are used to fill in the void areas at the bottom of the frame. Basically, this is completing a triangular composition, with the shoulders and arms forming the base of the triangle and the head at its peak.

Even when you include more of the subject than the typical head-and-shoulders pose, the body should be used to form a triangular composition. This is a helpful concept for many young photographers who are starting to learn the various poses, but have a hard time trying to decided where the bottom of the frame should be (waistline? thighs? knees?). I tell them to look for the bottom of the triangle and crop the portrait there. Whether the arms, hips, or knees are used to complete the bottom of the triangle, that should be the bottom of the frame or composition.

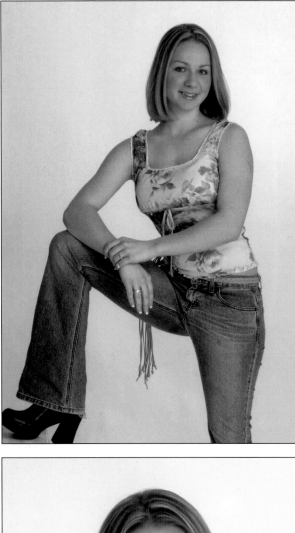

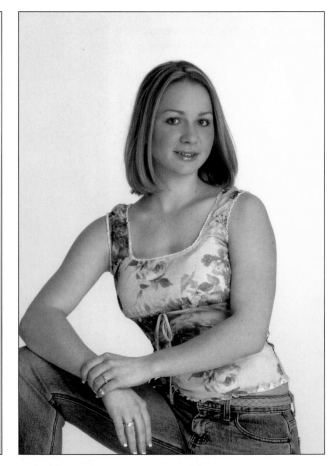

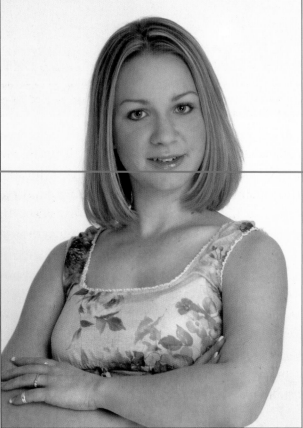

Many poses offer a photographer the ability to choose from different ways to compose the portrait. These work very well in high-volume photography studios, since you don't have to re-pose the subject for each shot.

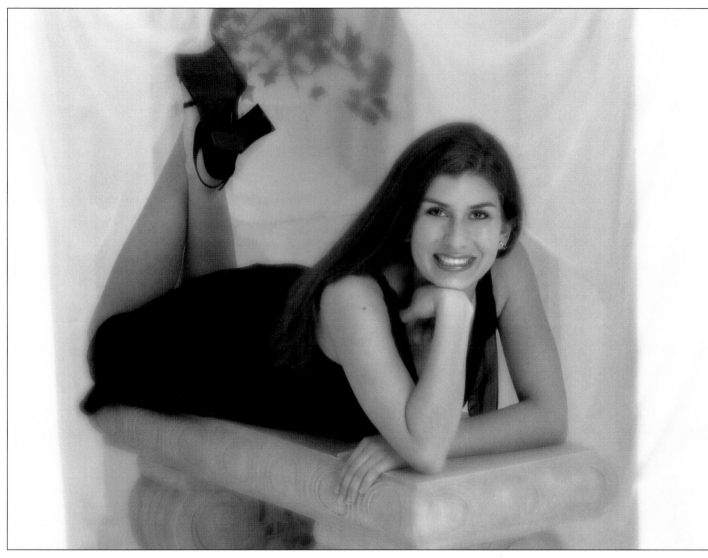

Here's another example of a pose that can be composed as a full-length image to show the subject's outfit and as a closeup that will make Mom happy. Note how the arms are used to create a triangular base for both compositions.

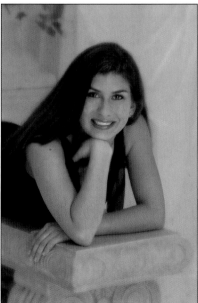

As you see in most of the photographs in this book, by using the body to fill the base of the composition you can ensure that the portrait appears finished. It looks as though the photographer put some thought into coordinating the pose with the final composition. In each type of pose (waist-up, thighs-up, knees-up, or full-length) the body is used to fill the bottom of the composition.

Many poses offer a photographer the ability to choose from different ways to compose the portrait. Poses like these work very well in high-volume photography studios. Once the subject (for us always a senior) is in the pose, a full-length or three-quarter pose is done for the senior (so she can see her entire outfit) and then a closeup is done to make Mom happy. Both are taken without having to re-pose the subject.

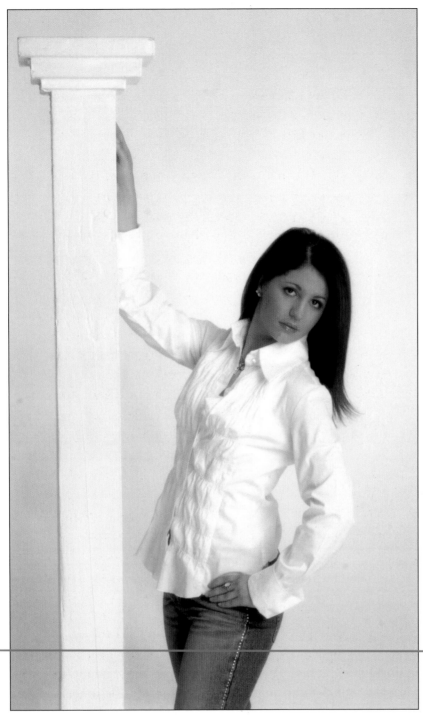

The client's shoulder's should never form a horizontal line through the frame.

■ The Shoulders

A client's shoulders form the compositional base for every head-and-shoulders pose you take. As mentioned previously, this base (the line of the shoulders) shouldn't form a horizontal line through the frame. A diagonal line makes the portrait more interesting and the subject less rigid.

The shoulders of a man should appear broad and at less of an angle than the shoulders of a woman. Women's shoulders can be a

A client's shoulders form the compositional base for every head-and-shoulders pose.

very appealing part of a portrait if posed properly. I like when my wife wears dresses that show off her shoulders. However, my wife is thin and very fit, unlike the majority of people we photograph each day. For this reason, it is always a good idea to have the shoulders covered with clothing if the subject's weight is at all an issue.

Clothing itself, however, can create problems in this area of the body. Large shoulder pads in a jacket, for example, will make just about any kind of posing impossible, making your client look like a football player. As you can imagine, this is good for skinny guys but not so good for larger guys or any woman.

Arms

In addition to the arms completing the composition in poses taken from the waist up, the arms should obviously be posed away from the body to define the waistline.

Long Sleeves. Arms often have problems that can only be hidden by clothing, which is why we suggest that everyone wear long sleeves. Models may have perfect arms, but our clients are plagued with a variety of problems—arms that are too large or too boney, loose skin, hair appearing in embarrassing places, stretch marks, bruises, veins, etc. The list is a long one, so cover those things up.

Don't Rely on Digital Fixes. By the way, many digital photographers just read that list of problems and thought, "I shoot digital, I can fix anything!" Well, no—you can't. Once we went digital, it took our staff about six months to get out of the "we can fix anything" mindset. Every time an employee told a client we could fix something, I would sit them down at

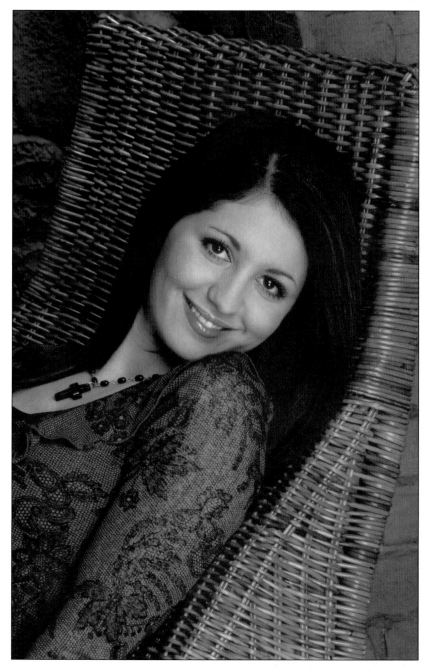

The arms are a problem area for many people, so we recommend that all of our clients choose outfits with long sleeves for their portraits.

a computer station and tell them to fix it. When they were still try-ing to make the area of the problem look natural an hour later, I would ask if we could "fix anything" or not. Time is money. As a rule of thumb, you shouldn't fix anything with digital that you did-n't use artwork from your outside lab to fix when you shot with film.

As more photographers change from film to digital, I think we will see a rise in studios going out of business, as well as a rise in the divorce rate. Photographers are getting so excited about what *can* be done, they don't stop and think if it *should* be done. As a result, they are investing much more time than they did with film, without generating any additional profit to pay for it.

Problems with posing need to be dealt with at the shoot, not fixed later. Your client needs to know how to dress to look their best

Problems with posing need to be dealt with at the shoot, not fixed later.

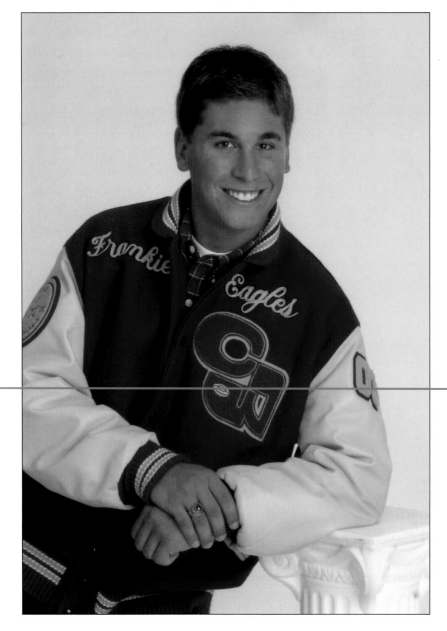

To learn how to pose arms effectively, spend some time observing people and notice how they naturally hold their arms.

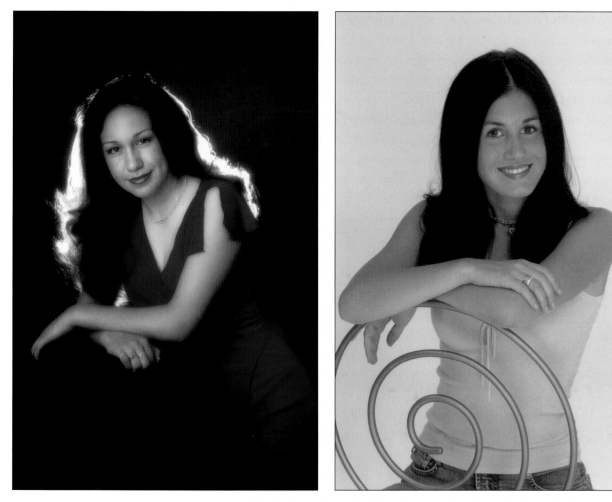

When the arms will be resting on something, try to put the weight on the elbow or rest the arms very lightly on each other to avoid having the biceps or forearms mushroom out and look larger than they are.

Potential problems need

to be addressed at the start

of the session.

and hide their flaws before the session day. If they don't wear the clothing that you have suggested, then they must be billed for the time it takes to fix the problems that their decision created. This information has to be given to them in writing (in a session brochure) or in the form of a video consultation. We use both, since we want even the most clueless clients to be aware of how they should dress and prepare for the session—and how much it could cost if they don't!

Explaining Problems with Tact. If a client decides not to heed your warnings, potential problems need to be addressed at the start of the session. If you see that your client is a larger woman and you also see sleeveless tops, you need to explain, "One area that women tend to worry about is their arms—either the size of the arms or hair on the forearm showing in the portrait. This is why we suggest wearing long sleeves. Now, you can try one sleeveless top, but most woman stick to long sleeves just to be safe." This is a nice way of telling your client, without embarrassing her, that her arms are too large for that kind of top. In referring to other clients and not specifically to her, you save her feelings and the final sale.

Posing the Arms. To learn how to pose the arms, watch people as they are relaxing. They fold their arms, they lean back and relax on one elbow, they lay on their stomachs and relax on both elbows, or they will use their arms to rest their chin and head.

Any time weight is put onto the arms (by resting them on the back of a chair, the knee, etc.) it should be placed on the bone of the elbow. If weight is put on the forearm or biceps area, it will cause the area to mushroom and make it appear much larger in size than it actually is. This is another reason to have the arms covered if it at all possible.

If weight is put on the forearm or biceps area, it will cause the area to mushroom.

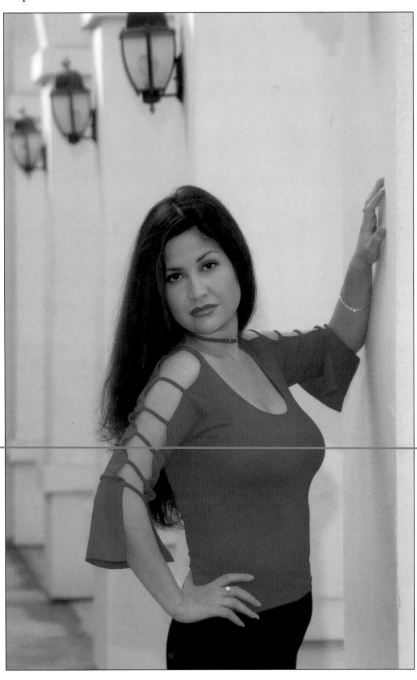

A pose is selected for many reasons. In this photograph, showing the cutouts of the blouse give the portrait more impact. Elevating the arm created an interesting line in the image, and giving it a place to rest makes the pose look natural.

If necessary, the arms can be used to conceal a problem area. For example, a pose like this could be used to conceal a subject's not-too-flat stomach.

Using the Arms to Conceal Problems. Posing the arms carefully also gives you the ability to hide problem areas, such as the neck, waistline, or hips. I look at the client once they are in the pose to see if there are any areas that, if I were them, I wouldn't want to see. If there is a double chin, I lower the chin onto the arms to hide it. If a see a not-so-flat stomach, I may extend the arms out to have the hands around the knees.

Observe the Details. The key to good posing is being observant. Many photographers are in too much of a hurry to start snapping off pictures. Now that we are digital, I tell my young photographers to take one shot and wait for that image to completely

Posing the arms carefully

also gives you the ability

to hide problem areas.

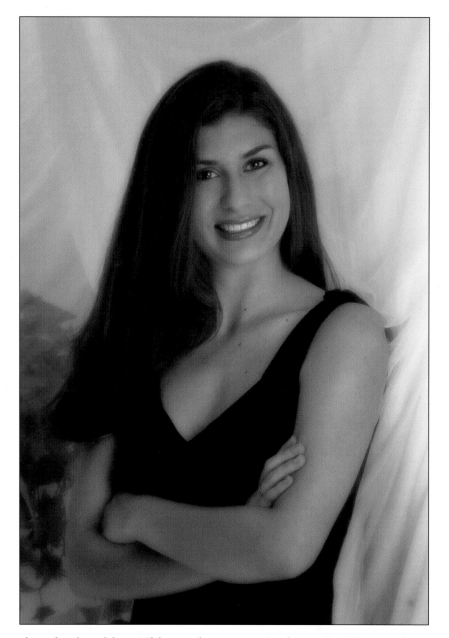

If you don't have a good eye for detail or a good sense of style, hire someone who does to assist you in your sessions. This will save you the cost of their salary in lost or reduced orders.

download and be visible on the screen. At that point, I want them to study the image for at least ten seconds. By forcing them to take the time to notice problems in posing, lighting, and expression, the number of obvious problems have gone down considerably.

Many photographers find that they don't have an eye for detail. They constantly find problems—problems they should have picked up on before the portrait was taken—coming out in the final proofs when they show them to the client. If this is your shortcoming, hire someone with a good eye for detail to assist you in your sessions. Their eyes and focus on detail will save you the cost of their salary in lost or reduced orders.

Within our studio, I do this often. We have a photographer who has been with us for some time. He, like most mature men, has no

Many photographers find that they don't have an eye for detail.

idea what makes one hairstyle look good and one look messy. I pair him up with one of our younger posers/set movers, who acts like she is a member of the fashion police. She can spot a stray hair or a bad outfit from across the studio. Between the two of them, we have excellent portraits for clients.

■ The Hands

If you think that photographers have a hard time gracefully dealing with the tilt of the head, you should see the way that some photographers deal with the hands. The hands are one of the most difficult areas of the human body to pose effectively. This is why so many photographers simply stick the hands into the pockets—out of sight, out of mind (or something like that). Many photographers rarely take portraits in which the hands show, and if they do show, they are hanging down to the client's side. Now that's artistry!

Bend Every Joint? When I first started in photography about twenty years ago, the hands were supposed to have every joint bent. As a result, it wasn't uncommon for a woman to look like she'd missed a payment to her bookie and he took a nutcracker to her fingers.

Let's face it, the "all joints bent" look is a little on the unnatural side—I don't know about you, but I never have every joint in my hand bent. Using this strategy makes your subject look like a mannequin from the 1960s. Also, when you have the hands posed in such a way, it can draw attention away from the face, the intended focal point of the portrait. While this works well for showing off a wedding ring (or, I suppose, if you are photographing a very

Hands should never just "hang there" in a portrait. Instead, give them something to do, even if it's just one lightly grasping the other.

Place the body and arms where you want them and then find a place for the hands to rest.

homely person with beautiful hands), it is a major distraction for most of your buying clients.

Give Them Something to Hold. Generally, the hands of both men and women photograph best when they have something to hold on to. They photograph worst when they are left dangling. The hands are one area of the body that clients usually pose very well on their own, if you explain where they are to place them or what they are to hold. If you watch people relaxing, in fact, you'll see that they tend to fold their hands or rest them on their body—instinctively avoiding the uncomfortable and unflattering "dangling" positions.

Place the body and arms where you want them, then find a place for the hands to rest, or something for them to hold. Hands *hold* and they *rest*, they shouldn't look like they are broken or take on the shape of a cow's udder (with the fingers hanging down). Following this rule simplifies the entire process, allowing you to achieve quick and flattering results while avoiding the very complex process that many photographers go through when posing the hands.

Fists. Guys don't always have to have their hands in a fist—and if they do, it should be a relaxed fist that doesn't look like they are about to join in on a brawl (if the knuckles are white, the fist is too tight).

> The hands photograph best when they have something to hold onto.

Having the subject hold something is a great way to pose the hands. Also, when guys have their hands in a fist, make sure it is a relaxed one.

Women should never have the hand in a complete fist. If a woman is to rest her head on a closed hand, try having her extend her index finger straight along the face. This will cause the rest of the fingers to bend naturally toward the palm, without completely curling into it. Even the pinky won't curl under to touch the palm.

■ Before Moving On to Full-Length Poses

In daily sessions, 90 percent of all the portraits you take will only involve the parts of the body that we have talked about this far. So stop reading for a little while and start to use what you have learned.

Practice on people who look like your buying clients, not like models. Experiment with ways of making the upper body and face look flawless. Photograph both men and woman, thin people and heavy people. Challenge yourself to observe every detail in every pose. Make sure that you know exactly what you are putting on film (or in your digital file). If you see one thing that was out of place or different than you thought it would be, go back and practice some more.

Practice not only remembering the poses you like, but refining those poses. Look to make each pose perfect, making each part of the body look good both as an individual element of the pose and

If you see one thing that was out of place, go back and practice some more.

If you can't consistently make head-and-shoulders images look great, you'll be in real trouble when it comes to posing the entire body.

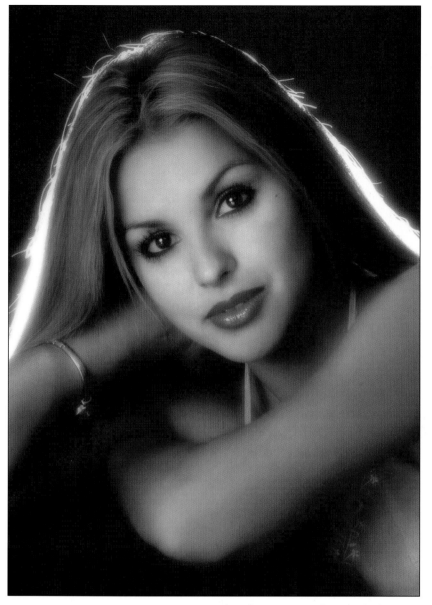

When you master the basic poses, move on to photographing head-and-shoulders poses that include the hands and require posing of the arms.

as a component of the final composition. Only when you can consistently make each part of the upper body look good and natural (and can do it quickly) should you start learning about posing the rest of the body.

Most photographers prefer practicing full-length poses, because they feel these are more artistic and offer more creative possibilities. I will tell you what I tell my photographers who are in a hurry to get into the main studio areas where the full-length poses are taken: You have to crawl before you walk, and walk before you can run. If you don't understand the elements of posing well enough to consistently make five areas of the body look great (face, neck, shoulders, arms, and hands) you have no chance of making the entire body look good.

Taking on the task of posing the entire body is overwhelming to young photographers. This is why young photographers in my studio start out with basic yearbook posing—they only have to deal with the face and shoulders. Then, as they master these basic poses, they move on to photographing head-and-shoulders poses that include the hands and require posing of the arms.

After they can confidently show clients five to eight variations on whatever pose they have selected, they are ready to start posing in the full-length areas. This process usually takes at least two years, so don't feel that, after reading this first section, you are going to nail the posing on your first test session. Posing is a discipline, so give yourself a break and allow yourself time to learn and develop a routine that works for you.

5. THE BUSTLINE AND THE WAISTLINE

I have put the bustline and waistline together because they have much in common. First of all, one is on top of the other, so you need to consider both when selecting the lighting, clothing, and posing since these choices will effect both areas. The second thing they share is the fact the photographers are normally either hiding them from the view of the camera or trying to enhance them.

■ Enhance or Conceal?

In 95 percent of all portraits, the bustline (or the chest, for male clients) and uncovered waistline are not visible and really don't need to be considered.

However, if you have a busty woman in a blouse that shows way too much cleavage for a business portrait, you will have to hide the bustline. If that same woman is taking a portrait for her husband, however, you will want to make the bustline appear as full and appealing as possible.

Similarly, imagine you are in a session with a man who works out and has a washboard stomach. If he wants to show off his muscles in a portrait for his wife, you could have him put on a jacket with no shirt underneath and leave it open. You would also want to use both lighting and posing to bring out the texture of the muscles in his stomach area.

Let's imagine, however, that a second man comes in who is—well, we won't say he's overweight, but he's eight to twelve inches too short for his current weight. If you show his stomach, you'll

Imagine you are in a session with a man who works out and has a washboard stomach . . .

Here are two images from a portrait series we'll return to later in the book. Notice, though, how a slight change in the pose can be used to emphasize or conceal the bustline.

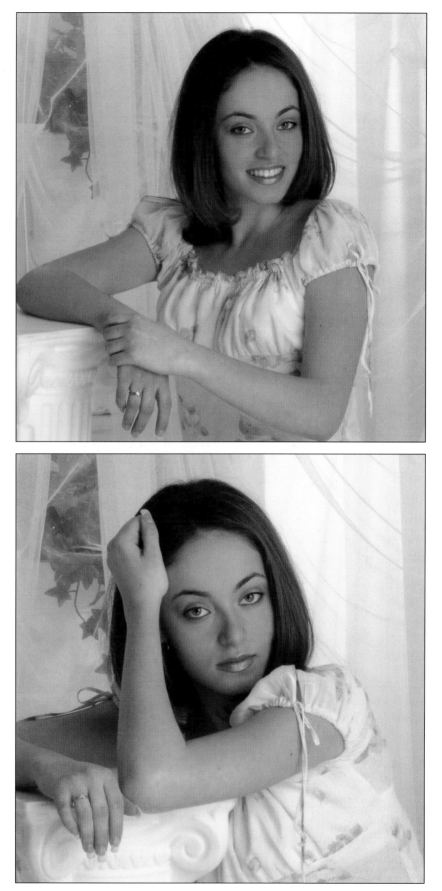

make him look like he's nine months along and expecting twins. In this case, the prudent thing to do would be to hide his stomach completely, which you can do with careful lighting and posing, and by pairing dark-colored clothing with a dark background.

Lighting and Posing. Hiding or enhancing the bustline or waistline really comes down to two factors: controlling highlights and shadows, and finessing the position of these body parts with respect to the main light. If the appearance of a large bustline would be completely inappropriate for the type of portrait being taken, dark clothing will help reduce the appearance of size. This is also an effective strategy for concealing a larger stomach area. With black especially, the distinct contours (the areas of highlight and shadow) that shape a bustline or belly don't show, making them seem smaller and flatter.

In the case of the bustline of a woman, size is determined by the appearance of shadow in the cleavage area or the shadow cast underneath the bustline. To increase the shadow in the cleavage area, you simply turn the subject away from the main light until you achieve the desired effect. To really make this area stand out, skim a kicker light from the side of the subject over both breasts. You won't be able to miss this area of the body when you look at the portrait. Using logic, to reduce the appearance of the bustline, you would simply reduce or eliminate the shadows in the same areas. This can be done by simply turning the body of the subject toward the main light.

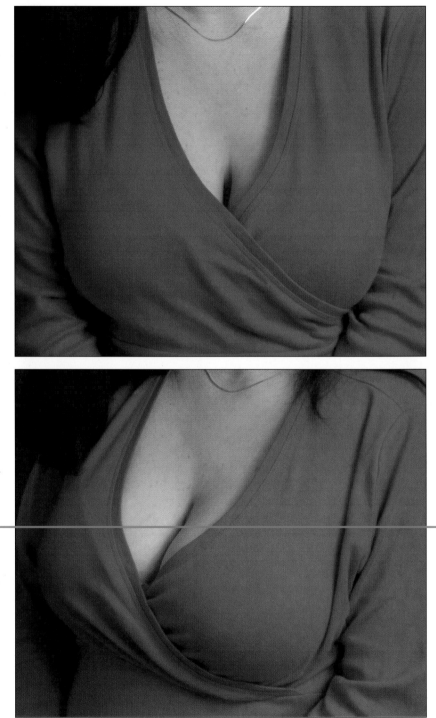

Simply turn the subject away from the main light to increase the shadows that enhance the shape of the bust.

The same lighting procedure can be used in the case of the man who wanted to show off his chiseled abs. By turning the body just enough toward the shadow side of the frame, you will create shadows in each recessed area. The larger the shadows, the larger the muscles look. For a final touch, a kicker light can be used from the side of the body—but make sure not to light up the shadows that you have just created. You want to make sure to keep the light at a low enough angle to just skim over the area you want highlighted.

The larger the shadows, the larger the muscles seem to be.

■ The Waistline

Angle to the Camera. As we have already discussed, the widest view of the waistline is when the body is squared off to the camera. The narrowest view of the waistline is achieved when the body is turned to the side. So the more you turn the waist to the side, the thinner it appears—unless there is a round belly that is defined by doing so.

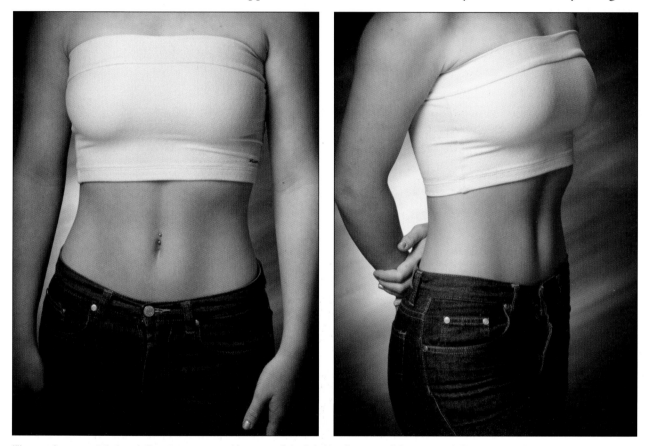

Women always want their waistlines to appear as thin as possible. Switching from a straight-on pose (left) to a pose with the body turned (right) helps to slim the waist.

Seated Subjects. A common problem with the waistline occurs when the subject is seated and the folds of skin (or stomach) go over the belt. Even the most fit, athletic person you know will have a roll if you have them sit down in a tight pair of pants. There are two ways to fix this problem. First, have the subject straighten their back

almost to the point of arching it. This will stretch the area and flatten it out. The second solution is to have the client put on a looser pair of pants.

Many photographers who lack an eye for detail also create the appearance of rolls simply by failing to fix the folds in a client's clothing around their waistline. Believe it or not, as a professional photographer you are responsible for every detail in every session (assuming you actually want to *sell* the portraits you are taking). That includes wrinkles in clothing.

In a seated position, clothing and skin wrinkle (left), giving even the thinnest person a roll. If the person is thin, simply have her straighten her back, almost to the point of arching it (right).

■ The Emotional Factors

As you have probably noticed, posing involves the emotions as much as the body—you must be tactful when discussing the client's appearance and sensitive when making decisions about how they will appear on film. If you fail to do this, you'll irritate or embarrass your client, and you *won't* sell portraits.

Technical Skills vs. People Skills. I love telling the story of a photographer I encountered one morning as he was working at the same outdoor location as I was. While the senior I was photographing was changing, I had nothing better to do than watch this other photographer work with his client. He told the young woman he was photographing to "sit her butt on the rock." I was intrigued at

If you fail to do this, you'll irritate

or embarrass your client . . .

the lack of professionalism he displayed in the way he talked to his client. The young lady sat down and her pant legs inched up revealing white socks that seemed to glow against her nearly black jeans. She looked down and asked, "Are my white socks going to show?" "Mr. Happy," as I'll call him, replied, "Of course they are going to show—if you didn't want them to show, you shouldn't have worn them!"

You get paid to make sure your clients look their best. Some tactful suggestions can easily solve little problems. For example, if the client brings the wrong shoes, you could suggest a barefoot portrait.

Many photographers reading this will of course think, "I would never act like that!" Well, guess what—behavior like this from photographers is much more common than you think. If you don't think so, talk with people who don't know your occupation and ask them their opinion of professional photographers. You will hear many stories, and you'll probably notice that the word "jerk" comes up a lot.

Mr. Happy could have composed the portrait closer to avoid showing the white socks. He could have told the girl to kick off her socks and shoes and go barefoot. He also could have said something that didn't make her feel like an idiot. Something like, "Don't worry, that's one thing that almost all our clients forget, we will just . . ."

You are paid to make sure your clients look their best, no matter how many bad choices in clothing, hair, and makeup they make. They may be overweight, they may be downright unattractive, but it is your job to make them look good, no matter what their individual situation.

Well, Mr. Happy went out of business a few years after I saw him. He is now selling shoes and is probably just as unsuccessful at that. I have seen many people like Mr. Happy come and go through

You can't create feeling in a portrait without being able to possess that feeling yourself.

the years. The common ground between them is that none of them have figured out that it isn't your magnificent technical skills that make you successful. Rather, it is your way of dealing with people that makes clients realize how magnificent your skills really are. What you think of yourself doesn't determine success, it is what your clients think of you that does.

It is all about compassion. If you can't understand the mistakes your clients make in preparing for the session, you can't have compassion for them.

Interpreting Emotions. Posing also deals with interpreting and conveying emotions. The way in which a body flows evokes a certain look or emotion from the viewer. This is one of the reasons why so many photographers have a hard time with it. They understand the technical side of photography but think it is unnecessary to understand the emotional aspects.

I had a photographer in the studio a few years back who was very skilled in setting up lighting, determining exposure, and all the

What you think of yourself doesn't determine success, it is what your clients think of you that does.

You can't deal with people effectively without understanding people and having compassion.

other nuts and bolts of photography. He was very up-front about the fact that he was going out on his own after spending a few years with us. I used to tell him that he knew more than enough about photography, but he needed to study life. He didn't understand what I meant by that.

I told him that you can't create feeling in a portrait without being able to possess that feeling yourself. You can't create a portrait that reflects love, if you don't have love in your heart. You can't deal with people effectively without understanding people and having compassion for the human condition. Successful photographers *feel* much more than they *know!*

Let's face it—a minimum-wage photographer at the mall can create a road map of a person's face. They might even be good at getting the subject to smile. So what makes you worth more than them? I have seen work by some studios that, quite frankly, would make me prefer to go to the mall. What sets professional photographers apart is their professionalism in handling clients and their abil-

If you want to set your work apart from the photographers at the mall, you need to be able to provide more than just a road map of the subject's face.

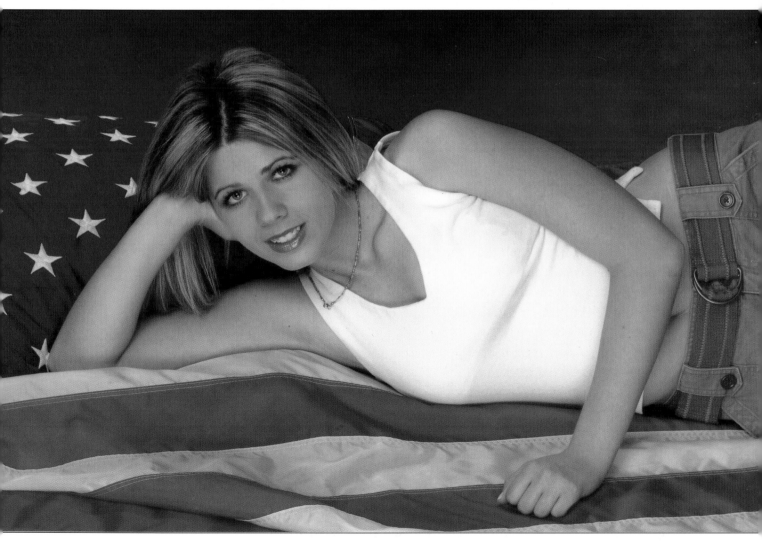

ity to create portraits that evoke an emotional response from the viewer. These are portraits that combine the right clothing with the right pose and are well coordinated with the background—images that bring everything together to achieve the desired feeling or emotion. It is only when a portrait has this sense of style, when it visually "makes sense" for lack of a better term, that a picture is considered a portrait.

Lasting Value. Many young photographers take a portrait and get excited. They are so impressed with their work of art that they order a studio sample from the lab to proudly display in their studio. When they get the print back from the lab, they are excited, but not as excited as when they first saw the pose. After about a month, their excitement for the image has passed and they think they made a mistake in selecting that pose for a sample.

This is what many clients go through. They get excited right after the images are created and make a purchase. If, however, the photographer has done his or her job and created a portrait that has a sense of style and evokes the desired emotional response, the client has a portrait that they will never tire of, even if the clothes and hairstyles become dated. If, on the other hand, the photographer *thinks* more than he *feels*, the client will tire quickly of the portrait, because it will have no emotion and will reveal no feeling to the viewer. It will be merely a road map with a big smile—a $200 road map that the client could have purchased at the mall for a great deal less.

When you look at a client with compassion, when you understand the areas of the body that we all worry about, when you judge the appearance of your client with the same "rose-colored

Truly successful portraits have more than just instant appeal; they have lasting value.

When you really care about your clients and creating lasting portraits for them, you'll find it's important to you to take the time to make sure each person looks their best.

... then and only then

will you create portraits that

achieve this sense of style.

glasses" that you (and everyone else) use when you look at yourself in the mirror, then and only then will you create portraits that achieve this sense of style.

At this point, it will become important to you to pull the wrinkles out of a sweater or spend a few extra moments trying to hide a large stomach. If you don't have it in you to care enough about your clients to do the job properly, you have two choices: hire someone who can work with your clients and remain a button-pusher, or get a regular job where bad attitudes and lack of compassion are tolerated.

6. HIPS AND THIGHS

This is probably the most important part of the body if you photograph women. While men gain weight in their double chins and stomachs, woman gain weight in their thighs. Unless you are a woman or live with a woman, you never will realize how much women worry about this part of their bodies.

■ Avoiding Full-Length Poses

The majority of portraits should not include this part of the body. (Full-length poses tend to be favored more by photographers than clients, anyway.) For any client with whom weight is a serious issue, it is especially important that you guide them away from poses that show the hips and thighs.

Notice I said "guide." Some photographers use about the same amount of tact as a football coach. On a good day, a client can expect to hear things like, "Well, with hips like yours . . ." or "You are a little hippy, so we probably shouldn't show them in the photograph."

Anytime you have to talk with a client because what she *wants* to do isn't what she *needs* to do to be happy with her session, you should use past clients as an example. A good way to explain that full-length poses shouldn't be taken would be, "Most woman go shopping for an entire outfit, and for that reason they want to take poses full length. However, a lot of women worry about their hips and thighs appearing heavy, so usually it is best to take the poses from the waist up. Now, is there anything you would like to do full-length poses, or do you want everything from the waist up?" Saying

Some photographers use about the same amount of tact as a football coach.

this, any woman who worries about weight will automatically choose to take everything from the waist up.

Most women are at least a little worried about the way their hips and thighs will look in their portraits. A simple solution? Don't shoot images that show them.

With carefully chosen words, clients can easily be led in the proper direction. As I've noted previously, we have clients pre-select the poses and background they want done in their session. Then, I will pose myself showing them the pose they have selected and additional poses that would also look good for the clothing and the background they have selected. If I know one of the poses would be best suited for the client, I use the same tactic described above. When I get to the pose that will slim their hips, I simply say, "Most woman worry about their hips and thighs looking as thin as possible, in posing this way, the hips and thighs look thinner. Now, which pose would you like to do?" Without exception, the slimming pose is the one that every woman will select—unless the subject is very thin.

■ Slimming the Hips and Thighs

Standing Poses. The first basic rule is never to square off the hips to the camera. This is obviously the widest view. In standing posing, rotate the hips to show a side view, turning them toward the shadow side of the frame if weight is at all an issue.

In standing poses, photographers often shift the weight of the hip to accent the hip closest to the camera. This works with a very thin or very curvy woman, but it enlarges the bottom and thigh, which isn't salable for 90 percent of women.

Just as the arms shouldn't be posed next to the body, legs (at the thighs) should never be posed right next to each other in standing

In standing poses, there should be separation between the legs. This can be accomplished by putting one foot up on something (left) or turning the body toward the shadow and pulling forward the leg closest to the camera (right).

poses. There should always be a slight separation between the thighs. This can be done by having a client put one foot on a step, prop, or set. Just turn the body to the side (the shadow side of the frame), and have the client step forward on the foot/leg that is closest to the camera. Alternately, you can simply have the client turn at an angle to the camera, put all their weight on the leg closest to the camera and then cross the other leg over, pointing their toe toward the ground and bringing the heel of the foot up. This type of posing is effective for both men and women.

Clothing also plays an important role in the appearance of the hips and thighs. The baggy clothing that has been popular for the past few years, and dress slacks for both men and women that are much less than form fitting, can sometimes make the thighs appear to be connected.

Seated Poses. More can be done to hide or minimize the hips and thighs in a seated rather than a standing pose, but there are still precautions that need to be taken to avoid unflattering poses.

If you sit a client down flat on their bottom, their rear end will mushroom out and make their hips and thighs look even larger. If, on the other hand, you have the client roll over onto the hip that is

Clothing also plays a role

in the appearance of the

hips and thighs.

closest to the camera, their bottom will be behind them and most of one thigh and hip will hidden.

Again, the legs must be separated, if possible. Obviously, if the client has on a short dress, this isn't possible. Instead, simply have move her lower leg back and bring her upper leg over the top of the lower one. If pants are worn in this same pose, the back foot can be over the front leg and the foot can be brought back toward the body, causing the knee to raise, again achieving a separation between the legs.

If pants are worn in

this same pose, the back foot

can be over the front leg . . .

When pants are worn in a seated pose, have the subject bring their back foot back toward their body, lifting their knees and separating their thighs.

Poses like these sell well because they look natural. Use the subject's arms or a lifted knee to finish the pose in a flattering way.

When you separate the legs, in this or any other pose, you need to make sure that the area between the legs (the crotch area) isn't unsightly. In the aforementioned pose, you may find this problem occurring when the subject is wearing baggy jeans. The problem also occurs when you have a guy seated with his legs apart, then have him lean forward and rest his arms on his knees. The pose works well because this is the way guys sit—and it sells well because it looks comfortable. The problem is that the crotch area is directly at the camera. In this situation, you can use the camera angle and the arms to hide or soften the problem area.

■ Look for Obstructions

To pose the human body effectively, you have to look for ways to cheat. Cheating isn't always a bad thing—especially in photography, where you can get well paid for it. When posing the hips and thighs, one of the best cheats is to use obstructions to hide the parts of the body that you know your client won't want to see.

In the Studio. You can use an arm, leg, or other part of the client's body, or when all else fails, start looking for a prop or portion of the set/background to hide or disguise the area. A well-

To pose the human body

effectively, you have to look

for ways to cheat.

placed pillow, plant, column, or tall grass can help you to achieve a much more flattering portrait of a client. When seniors bring in personal props, like trophies, sporting equipment, or collectibles, you can use them to soften the outline of the subject's body if weight is at all an issue. As they say, out of sight, out of mind.

Simple obstructions, like the back of a chair, can be used to conceal any part of the body that you don't want seen in the portrait.

Outdoors. Outdoor photography offers so many options, and many photographers just don't take advantage of them. I see photographers working at locations where they produce images that could have been created in the studio with a green screen!

Most photographers think in terms of subject and background—reducing a three-dimensional world into a two-dimensional one. Let

me explain what I mean. Most photographers will place the subject in a clearing with the selected background behind them. That is two-dimensional thinking. By placing the subject in the middle of what most photographers would call the background, however, you can create more of a third dimension. This is because you will have a foreground that leads to the subject and then a background that recedes farther and farther from the subject.

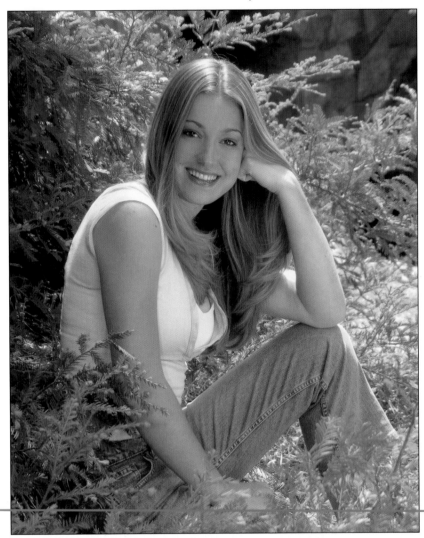

By placing the subject in the middle of what most photographers would call the background, however, you can create more of a third dimension.

The ready availability of these foreground scene elements, which can be used to hide clients' flaws, is one of the reasons I enjoy working outdoors. Something as simple as a tree trunk, bush, or grass in the foreground can hide any affliction, from large hips or stomachs, to white socks or even funky-colored toenail polish.

When you start looking for areas like this to pose your client, you not only create portraits that have much more dimension, but also make it possible to make your subject look their very best.

Groups. When you get into posing multiple people, you can use human obstructions, employing one person to hide the short-

A tree trunk in the foreground

can hide any affliction, from

large hips to white socks.

Look for foreground elements to

hide what you know the clients

won't want to see.

coming of another. If Dad has a large stomach, place Mom or one of the kids in front of this area to hide it. If the whole family is larger, you will find that no one wants to be in front. In this case, look for foreground elements to hide what you know the clients won't want to see.

■ Purpose of the Portrait

Photographers also have to be especially conscious of the purpose of the portrait when they are creating full-length poses. If a young woman wants a portrait to give to her grandmother, the posing will obviously need to be quite different than if she planned to give the portrait to her husband or boyfriend. Some photographers have a tendency to photograph all of their clients of the opposite sex in the

For every shoot, the photographer needs to determine the purpose of the portrait and design the image accordingly.

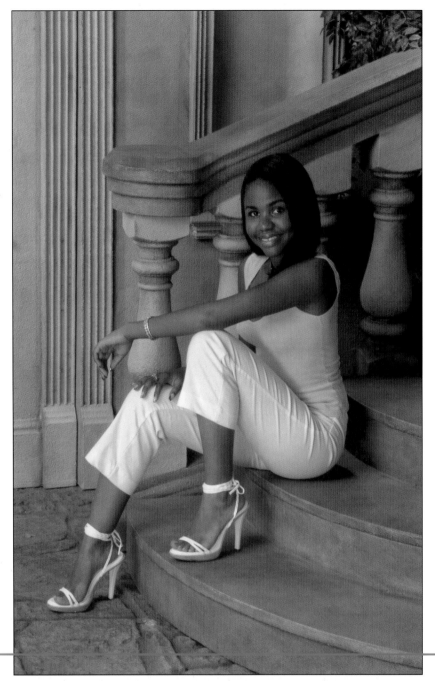

Most female clients want images that make them look feminine and attractive, but not like seductresses.

same way, no matter who the portrait is being taken for. Working with seniors, I can't count the number of seminars I have been to where photographers displayed images in which every senior girl looked like she was twenty-five and seeking employment in a gentlemen's club.

A client who is a mother wants to appear beautiful, but not like she belongs on the cover of a car magazine. A senior, at least to her parents, wants portraits that make her look like a beautiful seventeen-year-old person, not like a seductress. I know *I* would be proud of a portrait of my daughter in that pose—yeah, right!

A mother wants to appear beautiful, but not like she belongs on the cover of a car magazine.

■ Unusual Poses

Another problem that photographers have is overcoming the fear of posing clients in a way that may seem unusual to the person. In this pose of a senior and her mom (below), the two seemed very close. As I watched them during the session, I noticed that they seemed to have a lot of fun with each other. In the last pose, the senior wanted to include her mom. We placed Mom in the grass and had her daughter sit on mom's bottom leaning forward to rest on her shoulders. They loved it and used it for Christmas gifts for the entire family. It captured something I saw between them, while making them both look terrific.

I will be the first to tell you, when I asked the mother to lay down on her stomach, on the side of this hill, I received a puzzled look, but she did it because she believed in me as a professional. Most clients will do almost anything you ask them to if they believe

I noticed that they seemed to have a lot of fun with each other.

I received a puzzled look when I asked for this unusual pose, but the subjects went along with it because they trusted me as a professional. The result was an image of this close mom and daughter that they loved and used as Christmas gifts for the whole family.

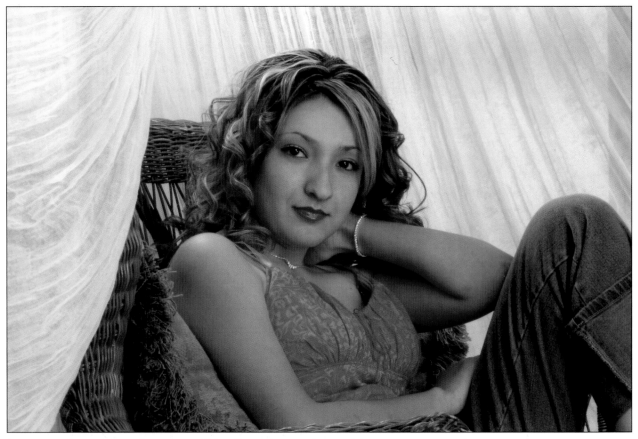

in you and trust that the pose will be flattering to the problem areas that all of us worry about.

■ Our Changing Bodies

As a society, we have become larger people. Fast food and little time to exercise have lead to a nation of overweight people. At the same time, our standard for beauty has become smaller. In the 1950s and '60s, women were "allowed" to have thick hips and thighs, but the current standard of beauty says that women should have the same body frame that most girls have when they are twelve to fifteen years old. Men aren't much better off. The standard has been raised, suggesting that every man should look like a model who has nothing better to do than work on his washboard stomach and tan.

We are all trying to reach the impossible dream, and creating that dream is what a photographer's job truly is. No photographer can make an overweight father or mother look like a swimsuit model, but if you understand the human side of this business and take the basic steps in effective posing, you can create something a client will be proud of—it won't be reality, but it will be a version of reality that the client's ego can live with.

It won't be reality, but it will be

a version of reality that

the client's ego can live with.

In turn, you will have the gratitude of a very happy client, and that gratitude can be deposited, invested, and used to provide you and your family with a very comfortable lifestyle.

7. THE FEET AND LEGS

Only a very small percentage of the poses you take in the average session will include these parts of the body. Just like every other part of the body below the waistline, if there is a reason not to include it, don't.

■ Feet

We will talk about the feet first. Other than the hips, there is no one part of the body as hated as the feet. While casual poses typically

Here, the feet are included, but their appearance is minimized by keeping them away from the camera and in shadow.

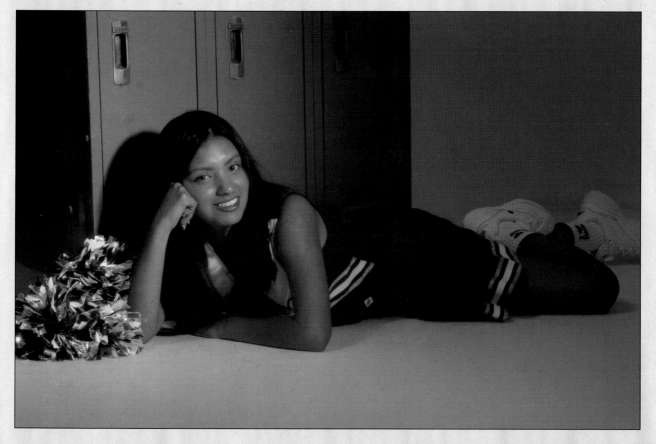

look good with bare feet, many people hate the appearance of their feet. I never knew how much the feet were hated until, eight or nine years ago, we started shooting seniors with bare feet. I would tell each senior who was taking more relaxed poses to kick off their shoes and socks—and I would see a look of horror come over the senior's face. The client would usually explain they hated their feet. Based on their reaction, I expected to see feet with seven toes.

Bare Feet. Clients don't want their feet to appear large, or their toes to look long. Also to be avoided are funky colors of toenail polish, long toe nails (especially on the guys), or (if possible) poses where the bottom of the feet show. If the bottom of the feet are to show, make sure they are clean.

Bare feet look smaller when the heels are pushed up. You can also use another part of the body or a foreground element to minimize the apparent size of the feet.

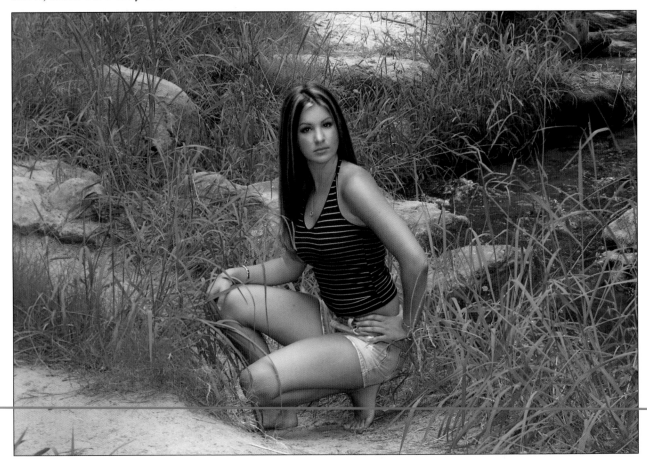

Minimizing the Apparent Size. Bare feet can be made to look smaller by pushing up the heels of the foot. This not only makes the feet look better, but also flexes the muscles in the calves of the legs, making them look more shapely. Muscle tone in the legs is determined by the muscle that runs down the outside of the upper and lower leg. Flex that muscle and the legs appear to be toned.

If the feet are showing with open-style shoes, the higher the heel, the smaller the foot appears. At this time, the really tall wedge shoes are popular, which also make the feet appear smaller.

The higher the heels, the smaller the subject's feet will look.

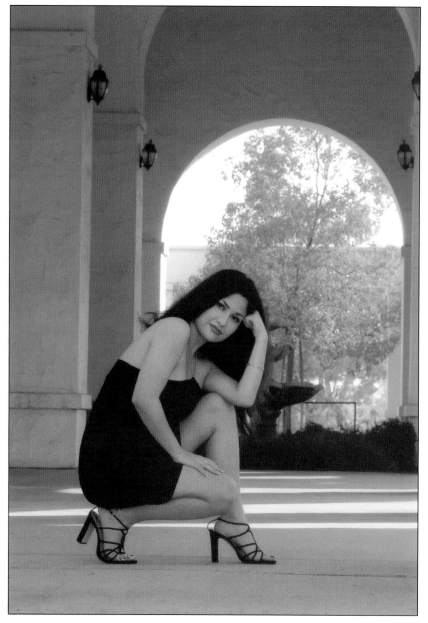

Posing the Toes. A client's tension becomes visible in their toes. If a person is nervous, their toes will either stick up or curl under. Neither one is exactly attractive. Just like the fingers, toes photograph better when they are resting on a surface.

Shoe Selection. The subject's footwear should reflect the feeling of his or her outfit. If the client is in an elegant dress, then high heels should be worn. Choose higher heels, in the 3- to 3½-inch range, to add an elegant look to the portrait, make the legs look great, and make the feet appear smaller.

If the client is in a business suit, shoes should be worn that reflect the professional look of the clothing. My wife once told me that you can tell how successful a person is by looking not at their suit, but their shoes. While most people (men especially) will buy

The subject's footwear

should reflect the feeling

of his or her outfit.

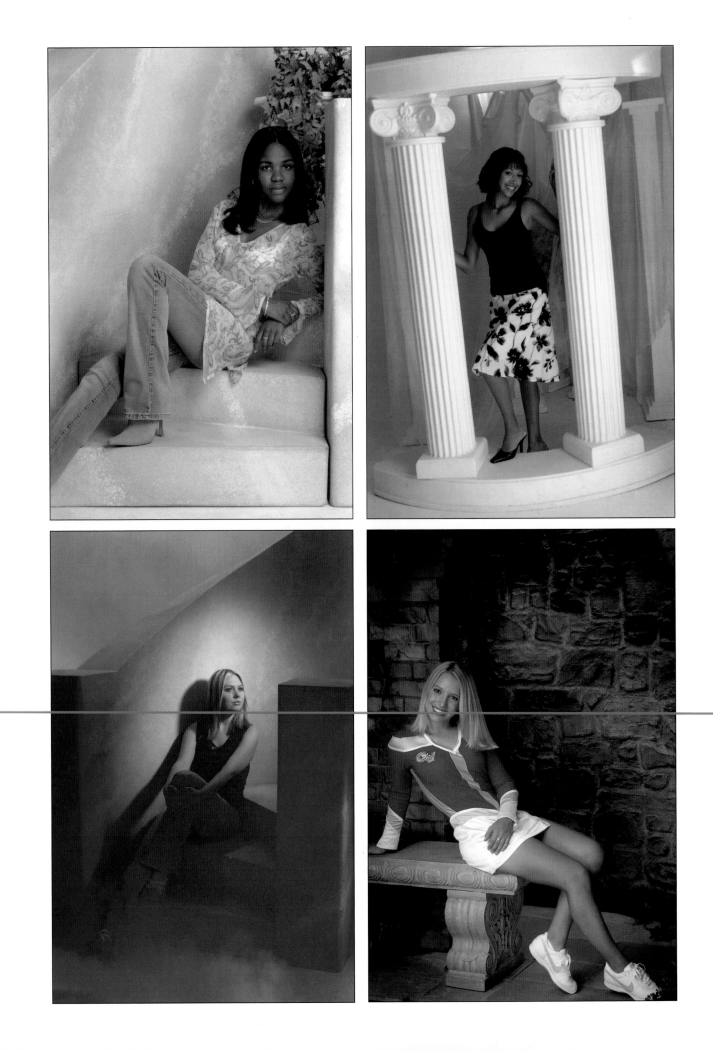

themselves a nice suit, only a successful person that knows how to dress will spend the extra money on a pair of shoes that is as nice as their suit.

As the clothing gets more casual, tennis shoes or bare feet are the best choices. Wearing socks without shoes really isn't a good idea.

Most of the time, shoe fashion really only matters with women. Men's shoes tend to fall into two categories, professional shoes and casual shoes, so there is little chance for mistakes. Women, however, have unlimited choices in the styles of their shoes, and usually own numerous pairs of shoes in any given style.

Since shoes are such a fashion statement with women, male photographers need to look for "foot fashion faux pas." There two things to look out for—both of which have to do with the size of the shoe compared with the size of the foot. If the shoe is too big,

Most of the time, shoe fashion really only matters with women.

The subject's shoes need to match their clothing. With women, the fashions may change quite a bit from outfit to outfit (facing page). With guys, shoes tend to be less varied and less prominent (right).

you'll notice a nice space between the back of the foot and the back of the shoe. If you see this, have the client take off her shoes and stuff tissue into the toe of the shoe, making it appear to fit. The other size problem occurs among women who insist on shoes that are too small. These ladies have their toes hanging over the front of the shoe and their heels hanging over the back. (A similar situation occurs among men who want to wear suits that used to fit twenty years ago.)

■ Legs

Ankles. Moving upward, you have the ankle and calf of the legs. This area is not a problem for most guys, but it can be a real issue for many women. The "cankle" (or the appearance of not having an ankle, but the calf of the leg just connecting to the foot) is a look that many women have and most could live without. This affliction is best handled by suggesting pants, looking for tall grass to camouflage the area, or taking the photographs from the waist up.

This area is not a problem for most guys, but it can be a real issue for many women.

Muscle Tone. As I said earlier, legs appear toned when the muscles that run along the outside of the thigh and calf are flexed and visible. (If the client's legs are very heavy, however, the muscles won't be visible even when flexed and the leg won't look toned.)

Having the subject wear pants is a simple way to eliminate many concerns about the appearance of the legs.

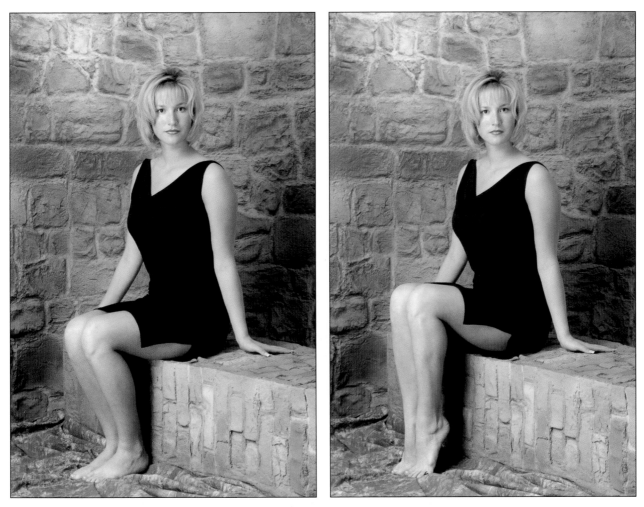

Lifting the heels, as they are in high-heeled shoes, makes the ankles and calves look more shapely (right) than leaving the heels flat on the floor (left).

These muscles usually become more readily apparent when the heels are raised, as they are with high heels, or by posing the feet with the heels elevated.

Legs are one of those areas of the body (like cleavage) that a woman either has, or doesn't. Let me make this clear: I am not saying that most of your clients don't *have* legs, but many of your clients shouldn't *show* them. Just because a woman is the correct gender, doesn't mean she looks good wearing a dress. When this is the case, it's time for some tough (but tactful) love.

Color and Nylons. If any part of the legs show, they should appear to have color—porcelain skin doesn't work on legs. If the subject's legs are very pale, suggest that she bring nylons. Darker nylons tend to look more elegant, while the flesh-toned ones look more "everyday."

For you men (and any ladies) with impaired fashion sense, nylons should *never* be worn with open-toed shoes, and reinforced toes should never, ever, ever be visible. Showing nylons with a reinforced toe is right up there with seeing grandma's knee-highs falling down below the hem of her housedress.

If the legs show, they should appear to have color—porcelain skin doesn't work on legs.

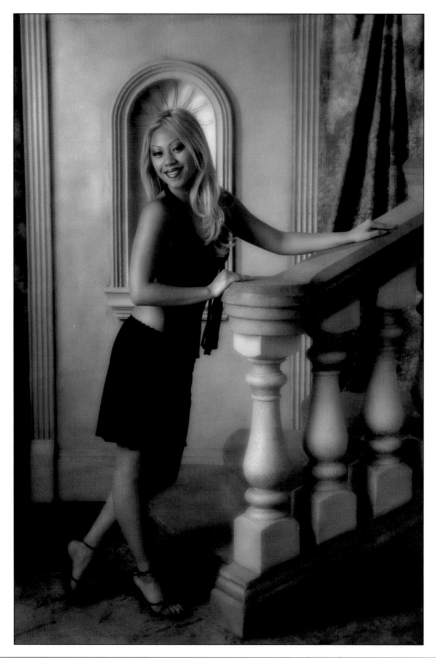

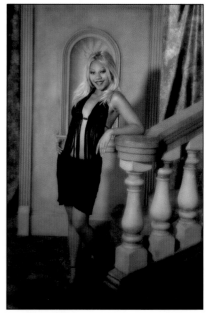

Fashion magazines reflect the standard of beauty for most clients, so ask them to bring in clippings that show poses they like.

Getting New Ideas. When getting new ideas for poses that include the legs, look at fashion magazines. These are the images that set the standard of beauty for your clients. Your clients don't want to look like mannequins, they want to look like the girls on the covers of these magazines. If the client doesn't have legs like those girls, suggest that she wear pants.

Leg Length. While you can hide large thighs, making legs look longer isn't easy. You can digitally lengthen them or use a wide-angle lens and have the subject extend their legs toward the camera, but both of these techniques have drawbacks. The problem with digital work, as was discussed earlier, is that someone has to pay for the time necessary to make these corrections. The problem with

When getting new ideas for poses that include the legs, look at fashion magazines.

using a wide-angle lens is that, while you will make the legs look longer, you will make the client's feet look enormous. So this technique only works on someone with really, really small feet.

Posing Techniques. The first advice I give to our young photographers about posing the legs is to pick what I call an "accent leg." Usually, the accent leg is determined by the pose and the direction of the body. This works in both standing, seated, and laying poses, leaving the other leg as the support or weight-bearing leg. If you use this strategy, you will have cut your work in half since you'll only need to pose one leg instead of two.

Take the classic "James Bond" pose. In this stance, the weight is put on one leg and the accent leg is crossed over with the toe of the

Usually, the accent leg is determined by the pose and the direction of the body.

To cut your leg-posing work in half, select one leg as the weight-bearing leg, then concentrate on posing the "accent" leg.

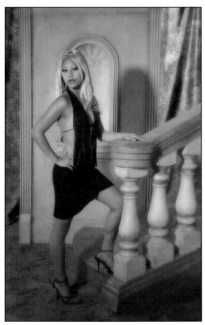

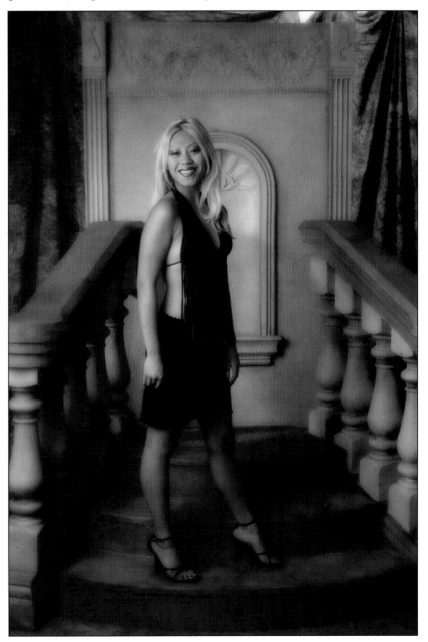

shoe pointing down. Similarly, if you have a woman standing on both feet, you should make one leg the support leg and the other the accent leg. If you have the accent leg angled to the side (rather than the toes pointing at the camera), it will make the pose look even more interesting and flatter the legs even more.

Even in a seated pose, one leg normally extends to the floor in order to, for lack of a better word, "ground" the pose. The body needs to be grounded. Have you have seen a person with short legs sit in a chair where their feet don't touch the ground? While this is

Even in a seated pose, one leg

normally extends to the floor

in order to ground the pose.

cute for little kids, a pose that is not grounded looks odd for an adult. If you have someone whose feet don't touch the ground, have them sit on the edge of the chair so at least one foot touches the ground, or have both feet brought up into the chair. This grounds the pose by using the chair as the base.

In a seated pose where one leg is grounded, the other leg becomes the accent leg. The accent leg can be "accented" by crossing it over the other, bending it to raise the knee, or folding it over the back of the head (just kidding)—but you need to do something with it to give the pose some style and finish off the composition.

The "Deadly Sins" of Leg Posing. There are literally hundreds of ways to make the legs (covered in pants or showing in a dress)

Do something to give the pose some style and finish off the composition.

With one leg pulled up, extending a leg to the floor makes the pose appear grounded.

look good. Again, it is easier to isolate what *not* to do, then move on to learning what *to* do. The deadly sins of posing the legs are:

Never do the same thing with both legs. Even a small variation will make the pose look much more polished.

1. In a standing pose, never put both feet flat on the ground in a symmetrical perspective to the body.
2. Never position the feet so close together that there is no separation between the legs/thighs.
3. Never do the same thing with each leg (with a few exceptions, like when both knees are raised side by side).
4. Never have both feet dangling; one must be grounded.
5. Never bring the accent leg so high that it touches the abdomen.
6. Don't ever expect one pose to work on everyone.

There is no one pose that will always work. Because of how flexible clients are (or are not), as well as how their bodies are designed, no single pose—no matter how simple it is—will make everyone look good. This is the golden rule of posing: when a client appears to be having a problem with a pose, scrap it. Don't struggle for five minutes trying to get it to work.

8. BRINGING IT ALL TOGETHER

In the previous chapters, you learned the six deadly sins of posing. You learned how to pose each part of the body. The next step is to bring everything together to achieve the look and style that will please the client. We have already discussed the element of style in a portrait, now it is time to put it to work. There are a few additional suggestions that I have for you as you work toward putting it all together.

■ Pose Every Image as a Full-Length Portrait

I suggest that you create every pose as if you were taking the portrait full length. This achieves two things. First, it speeds up the session by allowing you to go from head-and-shoulders, to three-quarters, to full-length with a zoom of the lens. Second, posing the entire body gives you practice in designing full-length poses.

I suggest that you create every pose as if you were taking the portrait full length.

This approach also makes the client feel complete. A certain look comes over a subject when they are posed completely and know they look good. If you don't think this is true, imagine how you would feel in an elegant dress with your arms and shoulders posed properly but your legs in some terribly awkward stance. It's like being dressed for success and looking good—right up until someone tells you your fly is open. Just take my word for it: pose the entire body—it's good for you *and* the client.

■ Analyze the Lines

When I start to teach my photographers how to pose the entire body, which is usually about two years after they have started with

Learn to identify the predominant lines in a composition. Here, the lines are almost all diagonals.

me, I have them go through the sample book and learn to identify the predominant lines in each pose, as well as in each scene. The predominant lines determine the overall feeling of the pose. Until you can identify these lines, you can't effectively pose a subject to achieve the desired look. And you thought once we got past the legs, we could start with the good stuff! This is the same feeling my photographers have. They usually say something along the lines of, "After two years of learning I still need to learn more?" That's right—the more you learn, the more you understand how much *more* you have to learn.

In posing, the predominant lines are either straight or curved. Straight lines in a pose give the image a linear, more structured appearance. Poses like these are often thought of as masculine, how-

ever I prefer to think they give the subject an appearance of being in command.

Curved lines have always been thought to be reserved for women. Anyone who has ever taken a class on wedding photography has heard of the classic S curve for posing the bride. This is an effective way to pose the body, but it isn't reserved just for the bride. Posing that has curved lines tends to be more elegant, more stylish, and is softer than linear posing.

◼ Take Control

As I've noted throughout this book, you really need to understand what you are creating to be able to plan your client's session appropriately. If you just go into the camera room and zip through your

In this variation on the image shown on the facing page, the predominant lines are more vertical, although the pose still contains a number of diagonal lines to draw your eye to the subject.

five favorite poses with every client, you lose and they lose. When you take control over your photographs, you can better produce exactly what your client is looking for. It's at this point that you can consider yourself a professional. You will also find that, when clients are truly satisfied, your bank account will grow with your ability.

To show this concept in action, I've created the following series of images using the same subject in different styles of clothing and tracking the session from her arrival at the studio. Notice how the background and posing changes as the clothes change, ensuring that each part of the portrait makes visual sense.

It's at this point that you can

consider yourself a professional.

Each session begins with the client deciding on the ideas that they want (and don't want) in their session. We have thirty sample books with twenty-four images in each, showing all the different backgrounds, sets, and posing options.

One of the assistants/set movers goes over the ideas and options with the client. They list all of the ideas on the client card, along with any notes about possible changes to the selected images.

The next step is to start coordinating the client's clothing with the backgrounds they selected. The assistant makes a list of which background each outfit is for, and notes any problems or corrections that need to be made.

My assistant explains the ideas to me, then I start working with the client. I demonstrate a variety of poses and let the client pick the pose they like the best.

With the client in the pose, the lights are adjusted and the camera position selected. Then my assistant and I make sure the client looks perfect—checking the pose, smoothing the hair, adjusting the clothes, etc.

Once the client's hair and clothing are perfect, we start photographing. We check our monitors once the first shot is taken to make sure that everything in the frame is the way we want it.

Sales also start during the session. For every full-length image we take, we also create a closer shot of the same (or a similar) idea to appeal to older family members.

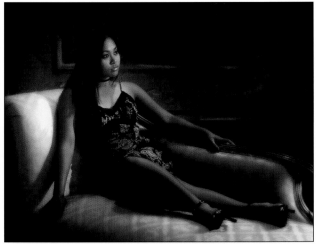

As the clothing style changes, so do the styles of backgrounds, props, and poses we use.

When selecting a pose, remember the areas of the body a client worries about the most. The best poses make the client look beautiful, while reducing the appearance of problem areas.

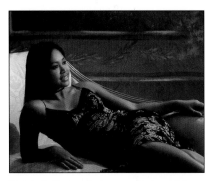

Variety is the key to happy clients and large sales. In each session, we have the client change at least three times and work with at least five different background or set combinations. Although there are many styles within these ideas, the elements all coordinate to create a planned sense of style.

So far, you've seen two combinations from this shoot (the casual motorcycle setup and the elegant setup on this page). On the next two pages are more variations from the same shoot. As you look through them, notice how the elements continue to be coordinated as we create a variety of images.

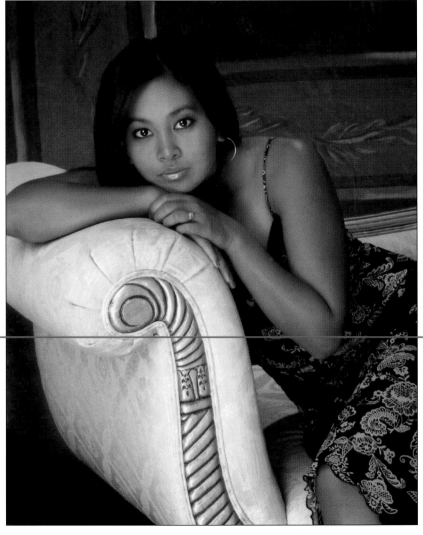

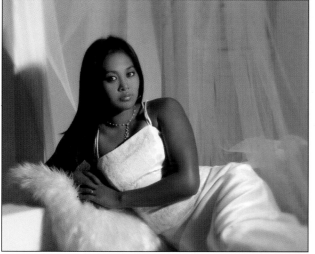

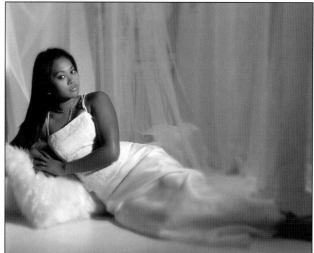

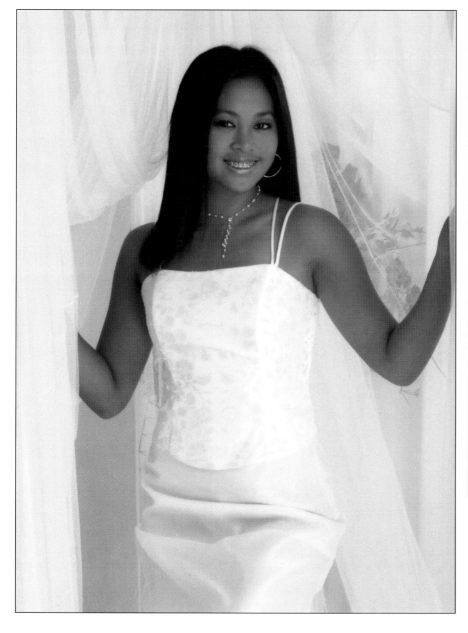

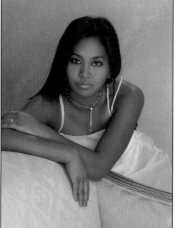

This elegant white outfit calls for classic poses and feminine backdrops and props.

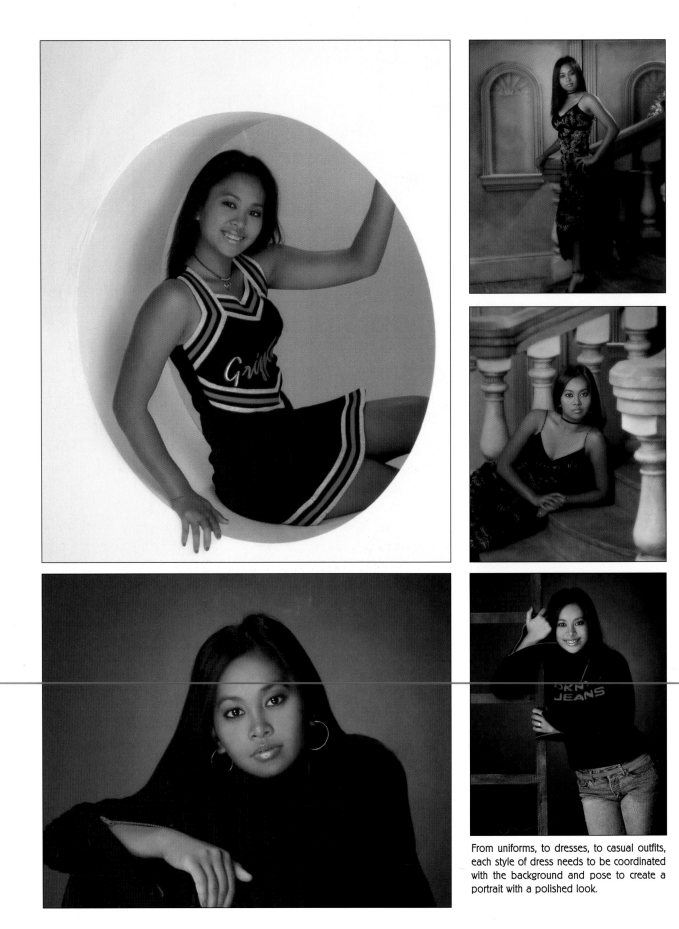

From uniforms, to dresses, to casual outfits, each style of dress needs to be coordinated with the background and pose to create a portrait with a polished look.

9. POSING MULTIPLE CLIENTS

Posing takes on a whole new dimension when it comes to arranging multiple subjects within the same composition. However, all the same rules for posing one person still apply to posing multiple people.

■ Proximity and Composition

As you pose the subjects within a group, it is important to keep a similar distance between each person. You don't have to take out a measuring tape; I said *similar*, not *exact*. The main idea is that if one person seems to be farther away from the group of faces and/or

Placing people physically close together also creates a sense of emotional closeness.

bodies than everyone else, they will look like they don't belong with the group. To keep people a similar distance visually, look to the face as a marker.

How close should you pose the people in the group? There are several factors to consider. First, you might want to choose a close grouping if there is a baby in the photo, lowering the adults down to the level of the baby. Tighter groupings are also good for families who want to create a sense of closeness in their portrait. Because closer groupings also isolate a small amount of a scene or background, they can be used when you don't need or want to show much of the setting.

How close should you pose the

people in the group?

If, on the other hand, your client wants to show more of the scene or wants large props (horses, cars, ATVs) in a pose, then the grouping will have to be spaced out to maintain a good composition.

In either case, a triangular composition is always a good starting place. It is always better than having no composition, which is what I see in many family portraits.

■ Head Placement

There are some old rules that have been very helpful to me when I have worked with posing more than one person.

The first word of advice is to never have anyone's head on the same level as another person's head. This can be challenging with larger groups, but it keeps the pose and composition from looking like a lineup. With fifty people, your posing options are limited, and you might have several people at the same height, but that's just life—and sometimes art must suffer when you need to photograph a gross of people.

In a photograph of two people, the mouth of the higher subject should be at about the same level as the eyes of the lower subject.

In a photograph of two people, the mouth of the higher subject should be at about the same level as the eyes of the lower subject. As you add more people to the composition, you may need to select a different point of reference—it may be that the eyes line up with the chin, or the top of the head lines up with the mouth, etc. Keeping this guideline in mind will help you to place each person within the group.

◾ Start with the Core

In posing a group, you should start out with the core people. This could be Mom and Dad, Grandpa and Grandma, a baby—it all depends on the portrait. Once the core is in place, you can start posing the additional people around that point of focus. As you add people, be sure to keep the distances between each person the same (or at least as close as possible). Start off with a triangular arrangement in mind and then modify it as you see fit.

◾ Your Best Work for Every Client

One final comment about families and groups. I started my studio in the little town I grew up in—a town with a population of around four thousand (not the best business choice I have ever made). I found the two areas of photography I excelled in were seniors and families and, to that end, I started studying and developing my skill in these fields. I became pretty good at posing family groups—in fact, I thought I was so good that I knew more about posing to please my clients than they did.

About three years after I opened my studio, I was hired by a Russian family to come to their home and take a family picture. They had no problem with the price I charged, but they refused to come in for a consultation and they said they knew what they wearing in the photograph, so there was no reason to discuss clothing either. On top of that, they said there was no need for me to come to their home to look at it before the day of the session, because it was going to be taken there and that was it. I hesitated before scheduling the appointment, but at that point in my career I needed every dime, so I booked it.

I arrived an hour before the session to look around the home and determine where to shoot. I was greeted by the grandmother, who promptly gave me an old photograph and explained that this was exactly what she wanted. It was five men standing and their five wives sitting on a plain bench in front of a white wall. Being a photographer with a healthy ego, I explained to her how many other ways we could take the portraits to make them more interesting and beautiful. She smiled, handed me the payment for the sitting fee,

> I thought I was so good that I knew more about posing to please my clients than they did.

and told me this old photo was exactly what she wanted.

Although I appeared calm and pleasant, inside I was furious. This is something that anyone could take. She could have had one of the kids snap off a picture with an instamatic and saved me the trouble. I almost felt guilty for taking what at that time was a fairly high sitting fee for such a crummy picture. They went into the pose, as though they rehearsed it. They did three groupings, all self-posed. Within an hour and fifteen minutes, I was done (that was ten minutes to set up, ten minutes to photograph, and fifty-five minutes of waiting).

On my drive back to the studio, I thought of how I was going to get stiffed. I would have my sitting fee, she would pick up the proofs, and I would never hear from her again. After the proofs came in, I called to let her

Anytime you think you know more about what your client should have then they do, they will prove you wrong.

know and, to my surprise, she said that the mother from each family would come to the studio and select what she wanted. Each mother, from each of the five families, ordered a 16x20-inch print for their homes. Each family also ordered a variety of smaller prints for their homes, offices, and to give to other family members. When all was said and done, what I thought was going to be the worst family sale ever turned into a total order that exceeded $3000.

The point to that very long story? Art is in the eye of the buyer, not the photographer. Anytime you think you know more about what your client should have than they do, they will prove you wrong. The second important lesson I learned is that you can't distinguish a large sale from a small one as you are doing the session. Yes, there are indicators as to what the person wants, but you never know what they will order until they order. This is why you always do your best with every session you photograph. Don't try to take shortcuts when you think that a client won't be spending as much on their order as you'd like them to.

You can't distinguish

a large sale from a small one

as you are doing the session.

In my career, I have had clients who drove a Mercedes and lived in huge homes spend $80 on portraits, complain about how much the order was, and then write a check that bounced to pay for it. At the same time, I have had people pull up in a car that looked as though the tires were going to fall off, spend $1500 on their order, thank me for the beautiful job I did, and then pay the total in cash. You never know, so you do your best with every client, no matter what your preconceived opinions are.

This is a hard lesson to teach your staff as well. They tend to put more effort into the sessions of affluent people than they do people from a lower economic level. Employees also tend to respond better to people who are from a similar economic level as the one they were raised in. Thus, if an employee comes from a poor upbringing, they tend to respond better to clients in that same economic class. If they had a privileged upbringing, they tend to respond better to people who are more affluent. The basic rule for you and your staff should be to treat each client with the respect and enthusiasm that you would expect to have from a professional service provider.

Posing a subject properly requires a knowledge about how to flatter the human form, an understanding of the elements of style and composition, and caring enough to give each of your clients what they want. While you can learn posing, style, and composition, it's much harder for some photographers to learn to really care about their clients—but if you don't learn how, don't worry, your clients will find a photographer who has!

Do your best with every client, no matter what your preconceived opinions are.

Treat each client with the respect and enthusiasm that you would expect to have from a professional service provider.

10. VARIATIONS

When I was first leaning posing, I had such a hard time with it. I would sit someone down and my mind would race, trying to figure out how to make the subject look comfortable and yet stylish. I would go to seminars and look in magazines to get posing ideas, but it seemed that when a paying client's session started the ideas went right out of my head.

We live in a world that has us looking for immediate solutions to long-term challenges. I see my sons trying to learn something new, and they get frustrated because they don't master it in the first five minutes. Whether it is lighting, learning digital, or especially posing, you won't get it the minute you put the book down. That would be like picking up a book on karate and thinking that when you finished reading it you would be a black belt. Posing is a learning process and, like all learning processes, it takes time and practice.

I realized, early on, that if I was going to become effective and comfortable with posing, I needed to practice often and in the same situations that I would be needing to use this skill. I needed to practice under the pressure of a session, not as I was fooling around shooting a test session of someone I knew. I also had the realization that I didn't have ten years to get good at posing my clients—I needed to get as many poses down as I could, and do it as quickly as possible. This led to what I call variations.

■ Practicing with Variations

Variations is an exercise I make every photographer in my studio use (including myself) in every session they do. It provides practice in

We live in a world that has all of us looking for immediate solutions to long-term challenges.

posing by taking each of the poses you know and really maximizing them. It also gives your client the maximum variety from each pose they do.

Variations are simple, yet effective changes you can make in a single pose to give it a completely different look. By changing the hands, arms, and/or legs in any pose, countless variations become possible. In the two sets of photographs that follow, you can see how variations work. You start out with a basic pose and come up with a variety of options for the placement of the hands, arms, and/or legs. This takes one posing idea you know and turns it into five or ten different poses.

Using variations can quickly turn one pose into five or ten (below and through page 119).

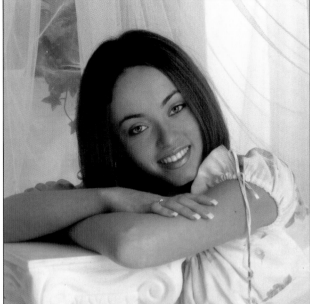

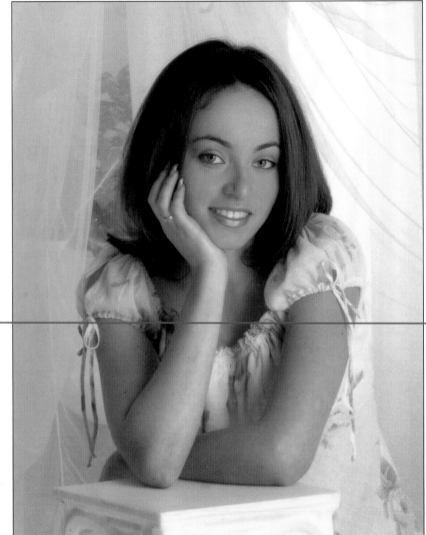

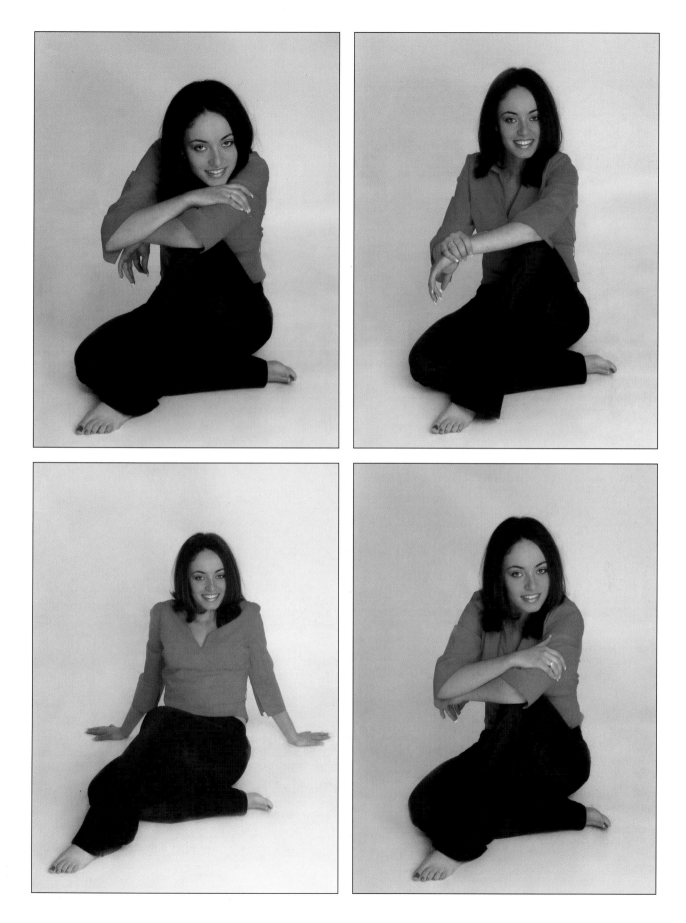

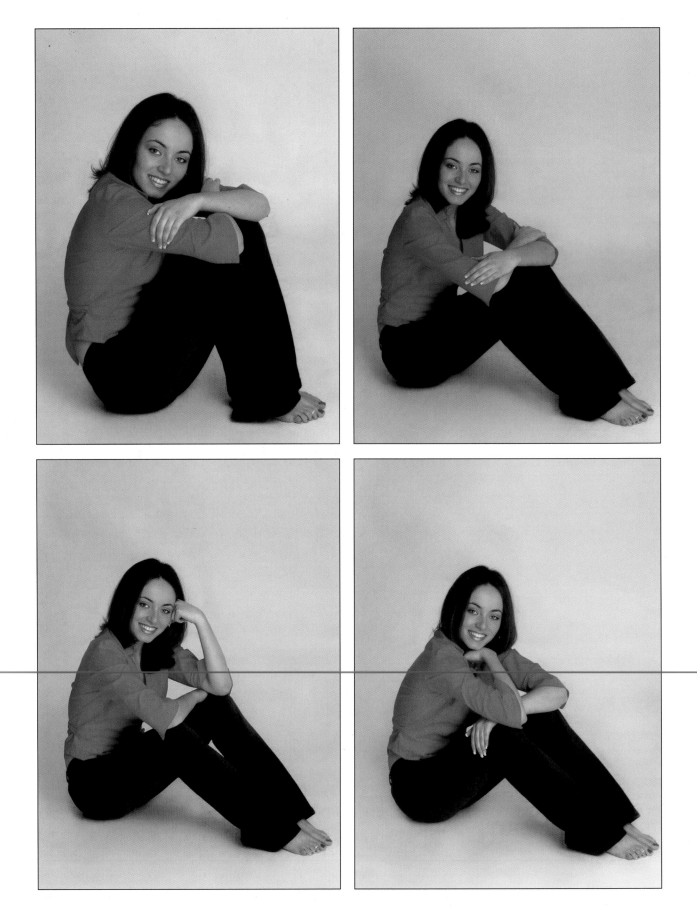

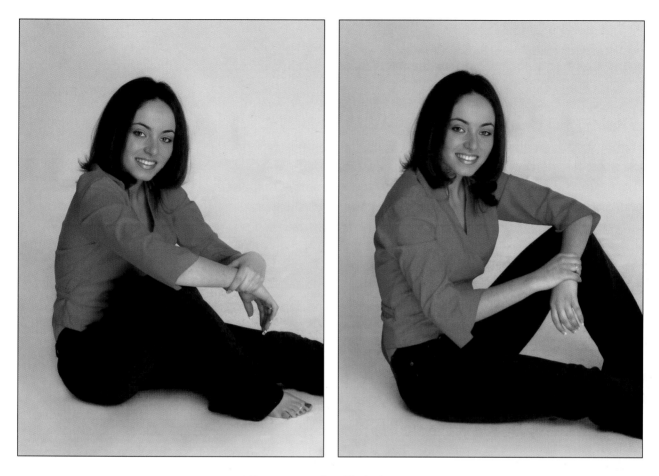

◼ Demonstrating Variations

As I've mentioned before, we have each client select the background and poses they want done in their session. These ideas are written on the client card for the photographers to follow. With each pose, the photographer is to demonstrate the client's selected pose, as well as show the client at least three other variations on the pose.

Male photographers hate this. I have heard it all—"How am I supposed to pose like a girl?" or "I feel really dumb!"—but I don't care how they feel. Until you can pose yourself, feel the way the pose is supposed to look, and demonstrate it to a client, you will never excel at posing. Yes, you get some pretty strange looks when you're not a petite man and you're showing a young girl a full-length pose for her prom dress, but that is the best learning situation I, or any other photographer, can be in.

That is best learning situation that I, or any other photographer, can be in.

◼ Keep Poses in Your Mind

Using variations keeps each of your poses in your mind, so no matter how much stress you feel, the poses are there. It's just like multiplication tables—once they stick in your mind, you'll never forget them. This is an important factor, since I have ten shooting areas in our main studio and often need to go as quickly as I can from one

shooting area to another, working with up to four clients at a time. As you can imagine, this requires some real speed at posing demonstration, as I assist each client into the desired pose and then refine it. Then I am off to the next client.

■ Helping Your Client Relax

Demonstrating posing variations will also help your client to relax in the pose. Just think of yourself doing any new task. You feel kind of nervous—especially if you have the extra pressure of wanting to look your best and do this task at the same time. Wouldn't you appreciate a person to guide you through the task and demonstrate how to do it as opposed to telling you to "go stand over there and do this"? We always need to put ourselves in our clients' shoes.

No matter how silly you might feel demonstrating variations, it is the most important part of the learning process. You can look at all the poses shown in this book, get clippings from magazines, and go to seminars, but until you practice them daily in the same situation as you will actually use them, designing flattering poses will always be a challenge to you.

Demonstrating posing variations will also help your client to relax in the pose.

Because I pull out the stops with

every client, I enjoy the success

this profession has brought to me.

Posing that makes a client look attractive is a goal for all professional photographers. When posing is also tailored to fit the purpose for which the portrait is to be taken, coordinates with the overall feeling and style you are creating for your client, *and* makes the client look outstanding, you are creating portraits that are worth every penny you charge for them.

Give your best to each client. So many photographers pull out all the stops for the beauty queens and just run through the session for those clients who are more "photographically challenged." You won't become the best photographer you can be by making beautiful people look beautiful; you'll become a better photographer when you learn to make everyone look good.

Every senior who walks into my studio, whether the child of the mayor or the child of a farm worker, gets my very best—because that is what every client deserves. Because I pull out the stops with every client, I enjoy the success this profession can bring. If you can develop the ability to see the beauty in each client, you too will enjoy one of the most fascinating professions in the world. If, like many photographers, you lump clients into two types (the beautiful, and the ones who make you work harder), you will find that your sales are pretty good on only about 25 percent of your clients. Good luck making a living with that kind of sales.

Look to learn, look to grow, and remember the words of my father, "As long as a man thinks of himself as green, he is growing; it's only when he considers himself grown that he begins to die." May you always be growing, and good luck on your journeys!

ABOUT THE AUTHOR

*J*eff Smith is a professional photographer and the owner of two very successful studios in central California. His numerous articles have appeared in *Rangefinder, Professional Photographer,* and *Studio Photography and Design* magazines. Jeff has been a featured speaker at the Senior Photographers International Convention, as well as at numerous seminars for professional photographers. He has written seven books, including *Outdoor and Location Portrait Photography, Corrective Lighting and Posing Techniques for Portrait Photographers, Professional Digital Portrait Photography,* and *Success in Portrait Photography* (all from Amherst Media®). His common-sense approach to photography and business makes the information he presents both practical and very easy to understand.

INDEX

Also by Jeff Smith . . .

Outdoor and Location Portrait Photography
2nd Ed.

Learn to work with natural light, select locations, and make clients look their best. Packed with step-by-step discussions and illustrations to help you shoot like a pro! $29.95 list, 8½x11, 128p, 80 color photos, index, order no. 1632.

Success in Portrait Photography

Many photographers realize too late that camera skills alone do not ensure success. This book will teach photographers how to run savvy marketing campaigns, attract clients, and provide top-notch customer service. $29.95 list, 8½x11, 128p, 100 color photos, order no. 1748.

Corrective Lighting and Posing Techniques for Portrait Photographers

Learn to make every client look his or her best by using lighting and posing to conceal real or imagined flaws—from baldness, to acne, to figure flaws. $29.95 list, 8½x11, 120p, 150 color photos, order no. 1711.

Professional Digital Portrait Photography

Because the learning curve is so steep, making the transition to digital can be frustrating. Author Jeff Smith shows readers how to shoot, edit, and retouch their images—while avoiding common pitfalls. $29.95 list, 8½x11, 128p, 100 color photos, order no. 1750.

Lighting for People Photography, 2nd Ed.
Stephen Crain

A guide to lighting for portraiture. Includes: setups, equipment information, strobe and natural lighting, and much more! Features diagrams, illustrations, and exercises for practicing the techniques discussed in each chapter. $29.95 list, 8½x11, 120p, 80 b&w and color photos, glossary, index, order no. 1296.

Studio Portrait Photography of Children and Babies, 2nd Ed.
Marilyn Sholin

Work with the youngest portrait clients to create cherished images. Includes techniques for working with kids at every developmental stage, from infant to preschooler. $29.95 list, 8½x11, 128p, 90 color photos, order no. 1657.

Wedding Photography
CREATIVE TECHNIQUES FOR LIGHTING AND POSING, 2nd Ed.
Rick Ferro

Creative techniques for lighting and posing wedding portraits that will set your work apart from the competition. Covers every phase of wedding photography. $29.95 list, 8½x11, 128p, 80 color photos, index, order no. 1649.

Photo Retouching with Adobe® Photoshop® 2nd Ed.
Gwen Lute

Teaches every phase of the process, from scanning to final output. Learn to restore damaged photos, correct imperfections, create realistic composite images, and correct for dazzling color. $29.95 list, 8½x11, 120p, 100 color images, order no. 1660.

Wedding Photojournalism
Andy Marcus

Learn to create dramatic unposed wedding portraits. Working through the wedding from start to finish, you'll learn where to be, what to look for, and how to capture it. $29.95 list, 8½x11, 128p, 60 b&w photos, order no. 1656.

Posing and Lighting Techniques for Studio Photographers
J. J. Allen

Master the skills you need to create beautiful lighting for portraits. Posing techniques for flattering, classic images help turn every portrait into a work of art. $29.95 list, 8½x11, 120p, 125 color photos, order no. 1697.

Make-up Techniques for Photography

Cliff Hollenbeck

Step-by-step text and illustrations teach you the art of photographic make-up. Learn to make every portrait subject look his or her best with great styling techniques for black & white or color photography. $29.95 list, 8½x11, 120p, 80 color photos, order no. 1704.

Portrait Photographer's Handbook

Bill Hurter

Bill Hurter has compiled a step-by-step guide to portraiture that easily leads the reader through all phases of portrait photography. This book will be an asset to experienced photographers and beginners alike. $29.95 list, 8½x11, 128p, 100 color photos, order no. 1708.

Professional Marketing & Selling Techniques for Wedding Photographers

Jeff Hawkins and Kathleen Hawkins

Learn the business of wedding photography. Includes consultations, direct mail, advertising, internet marketing, and much more. $29.95 list, 8½x11, 128p, 80 color photos, order no. 1712.

Traditional Photographic Effects with Adobe® Photoshop®, 2nd Ed.

Michelle Perkins and Paul Grant

Use Photoshop to enhance your photos with handcoloring, vignettes, soft focus, and much more. Every technique contains step-by-step instructions for easy learning. $29.95 list, 8½x11, 128p, 150 color images, order no. 1721.

Master Posing Guide for Portrait Photographers

J. D. Wacker

Learn the techniques you need to pose single portrait subjects, couples, and groups for studio or location portraits. Includes techniques for photographing weddings, teams, children, special events and much more. $29.95 list, 8½x11, 128p, 80 photos, order no. 1722.

The Art of Color Infrared Photography

Steven H. Begleiter

Color infrared photography will open the doors to a new and exciting photographic world. This book shows readers how to previsualize the scene and get the results they want. $29.95 list, 8½x11, 128p, 80 color photos, order no. 1728.

High Impact Portrait Photography

Lori Brystan

Learn how to create the high-end, fashion-inspired portraits your clients will love. Features posing, alternative processing, and much more. $29.95 list, 8½x11, 128p, 60 color photos, order no. 1725.

The Art of Bridal Portrait Photography

Marty Seefer

Learn to give every client your best and create timeless images that are sure to become family heirlooms. Seefer takes readers through every step of the bridal shoot, ensuring flawless results. $29.95 list, 8½x11, 128p, 70 color photos, order no. 1730.

Beginner's Guide to Adobe® Photoshop® 2nd Ed.

Michelle Perkins

Learn to effectively make your images look their best, create original artwork, or add unique effects to any image. Topics are presented in short, easy-to-digest sections that will boost confidence and ensure outstanding images. $29.95 list, 8½x11, 128p, 300 color images, order no. 1732.

Professional Techniques for Digital Wedding Photography, 2nd Ed.

Jeff Hawkins and Kathleen Hawkins

From selecting equipment, to marketing, to building a digital workflow, this book teaches how to make digital work for you. $29.95 list, 8½x11, 128p, 85 color images, order no. 1735.

Lighting Techniques for High Key Portrait Photography

Norman Phillips

Learn to meet the challenges of high key portrait photography and produce images your clients will adore. $29.95 list, 8½x11, 128p, 100 color photos, order no. 1736.

Professional Digital Photography

Dave Montizambert

From monitor calibration, to color balancing, to creating advanced artistic effects, this book provides those skilled in basic digital imaging with the techniques they need to take their photography to the next level. $29.95 list, 8½x11, 128p, 120 color photos, order no. 1739.

Group Portrait Photographer's Handbook

Bill Hurter

With images by top photographers, this book offers timeless techniques for composing, lighting, and posing group portraits. $29.95 list, 8½x11, 128p, 120 color photos, order no. 1740.

LIGHTING AND EXPOSURE TECHNIQUES FOR
Outdoor and Location Portrait Photography

J. J. Allen

Meet the challenges of changing light and complex settings with techniques that help you achieve great images every time. $29.95 list, 8½x11, 128p, 150 color photos, order no. 1741.

The Art and Business of High School Senior Portrait Photography

Ellie Vayo

Learn the techniques that have made Ellie Vayo's studio one of the most profitable senior portrait businesses in the US. $29.95 list, 8½x11, 128p, 100 color photos, order no. 1743.

The Art of Black & White Portrait Photography

Oscar Lozoya

Learn how Master Photographer Oscar Lozoya uses unique sets and engaging poses to create black & white portraits that are infused with drama. Includes lighting strategies, special shooting techniques and more. $29.95 list, 8½x11, 128p, 100 duotone photos, order no. 1746.

The Best of Wedding Photography

Bill Hurter

Learn how the top wedding photographers in the industry transform special moments into lasting romantic treasures with the posing, lighting, album design, and customer service pointers found in this book. $29.95 list, 8½x11, 128p, 150 color photos, order no. 1747.

The Best of Children's Portrait Photography

Bill Hurter

Rangefinder editor Bill Hurter draws upon the experience and work of top professional photographers, uncovering the creative and technical skills they use to create their magical portraits. $29.95 list, 8½x11, 128p, 150 color photos, order no. 1752.

Wedding Photography with Adobe® Photoshop®

Rick Ferro and Deborah Lynn Ferro

Get the skills you need to make your images look their best, add artistic effects, and boost your wedding photography sales with savvy marketing ideas. $29.95 list, 8½x11, 128p, 100 color images, index, order no. 1753.

Web Site Design for Professional Photographers

Paul Rose and Jean Holland-Rose

Learn to design, maintain, and update your own photography web site. Designed for photographers, this book shows you how to create a site that will attract clients and boost your sales. $29.95 list, 8½x11, 128p, 100 color images, index, order no. 1756.

PROFESSIONAL PHOTOGRAPHER'S GUIDE TO
Success in Print Competition

Patrick Rice

Learn from PPA and WPPI judges how you can improve your print presentations and increase your scores. $29.95 list, 8½x11, 128p, 100 color photos, index, order no. 1754.

PHOTOGRAPHER'S GUIDE TO
Wedding Album Design and Sales

Bob Coates

Enhance your income and creativity with these techniques from top wedding photographers. $29.95 list, 8½x11, 128p, 150 color photos, index, order no. 1757.

The Best of Portrait Photography

Bill Hurter

View outstanding images from top professionals and learn how they create their masterful images. Includes techniques for classic and contemporary portraits. $29.95 list, 8½x11, 128p, 200 color photos, index, order no. 1760.

THE ART AND TECHNIQUES OF
Business Portrait Photography

Andre Amyot

Learn the business and creative skills photographers need to compete successfully in this challenging field. $29.95 list, 8½x11, 128p, 100 color photos, index, order no. 1762.

The Best of Teen and Senior Portrait Photography

Bill Hurter

Learn how top professionals create stunning images that capture the personality of their teen and senior subjects. $29.95 list, 8½x11, 128p, 150 color photos, index, order no. 1766.

PHOTOGRAPHER'S GUIDE TO
The Digital Portrait

START TO FINISH WITH ADOBE® PHOTOSHOP®

Al Audleman

Follow through step-by-step procedures to learn the process of digitally retouching a professional portrait. $29.95 list, 8½x11, 128p, 120 color images, index, order no. 1771.

The Portrait Book

A GUIDE FOR PHOTOGRAPHERS

Steven H. Begleiter

A comprehensive textbook for those getting started in professional portrait photography. Covers every aspect from designing an image to executing the shoot. $29.95 list, 8½x11, 128p, 130 color images, index, order no. 1767.

Digital Photography for Children's and Family Portraiture

Kathleen Hawkins

Discover how digital photography can boost your sales, enhance your creativity, and improve your studio's workflow. $29.95 list, 8½x11, 128p, 130 color images, index, order no. 1770.

Professional Strategies and Techniques for Digital Photographers

Bob Coates

Learn how professionals—from portrait artists to commercial specialists—enhance their images with digital techniques. $29.95 list, 8½x11, 128p, 130 color photos, index, order no. 1772.

Lighting Techniques for Low Key Portrait Photography

Norman Phillips

Learn to create the dark tones and dramatic lighting that typify this classic portrait style. $29.95 list, 8½x11, 128p, 100 color photos, index, order no. 1773.

The Best of Wedding Photojournalism

Bill Hurter

Learn how top professionals capture these fleeting moments of laughter, tears, and romance. Features images from over twenty renowned wedding photographers. $29.95 list, 8½x11, 128p, 150 color photos, index, order no. 1774.

Color Correction and Enhancement with Adobe® Photoshop®

Michelle Perkins

Master precision color correction and artistic color enhancement techniques for scanned and digital photos. $29.95 list, 8½x11, 128p, 300 color images, index, order no. 1776.

Fantasy Portrait Photography

Kimarie Richardson

Learn how to create stunning portraits with fantasy themes—from fairies and angels, to 1940s glamour shots. Includes portrait ideas for infants through adults. $29.95 list, 8½x11, 128p, 60 color photos index, order no. 1777.